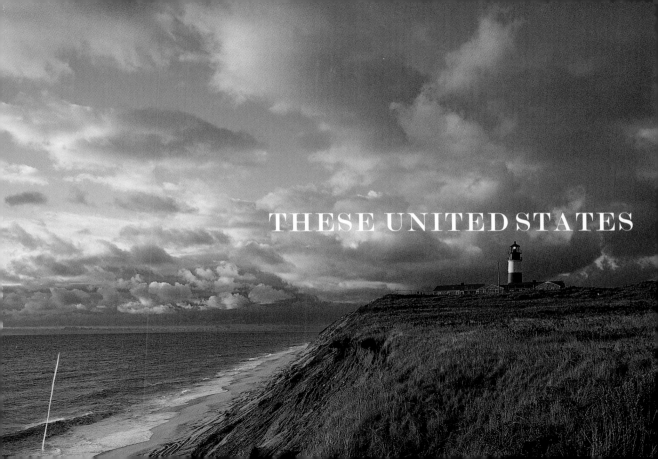

THESE UNITED STATES

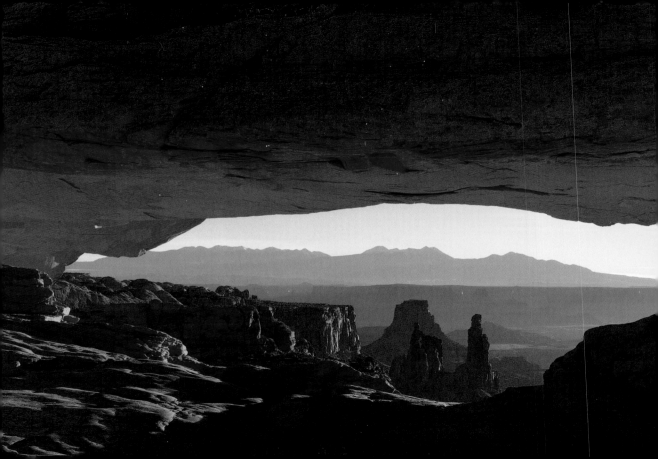

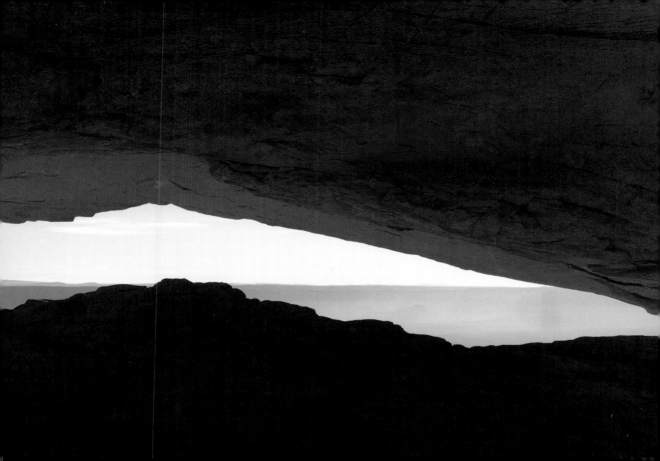

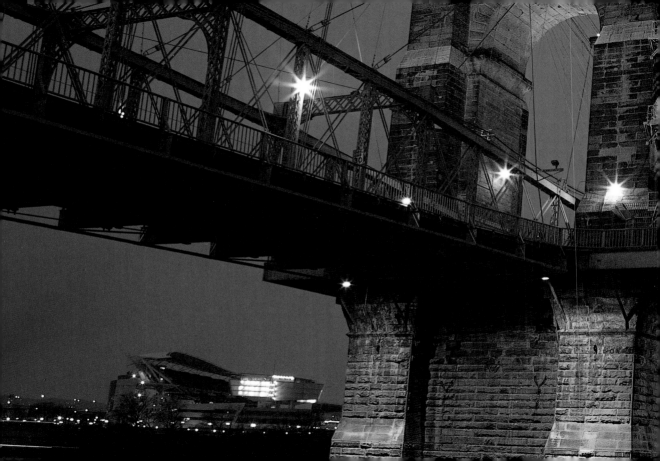

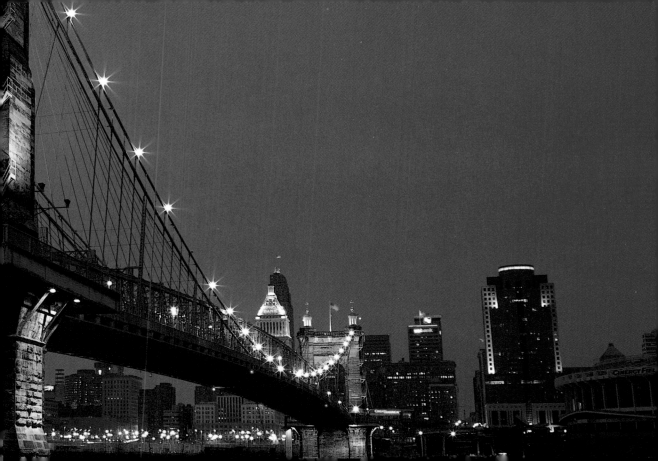

THESEUNIT

ED STATES

PHOTOGRAPHS BY JAKE RAJS INTRODUCTION BY WALTER CRONKITE

RIZZOLI
NEW YORK

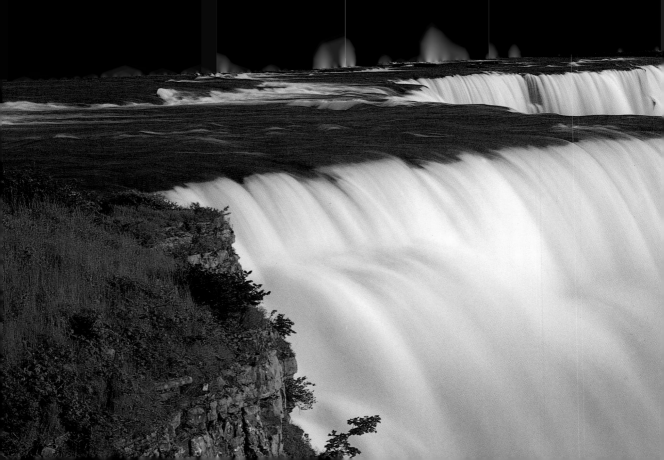

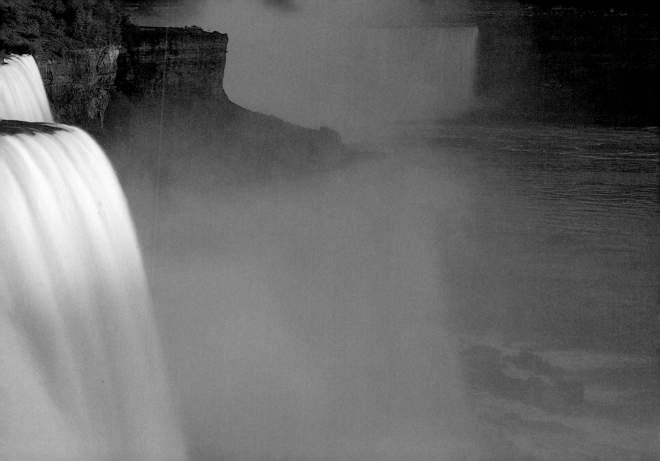

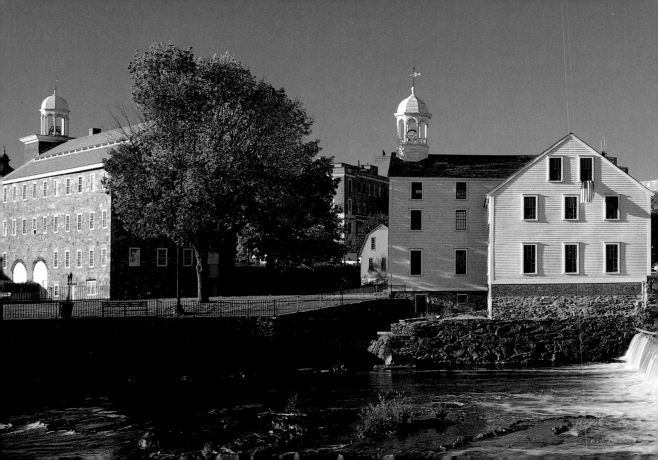

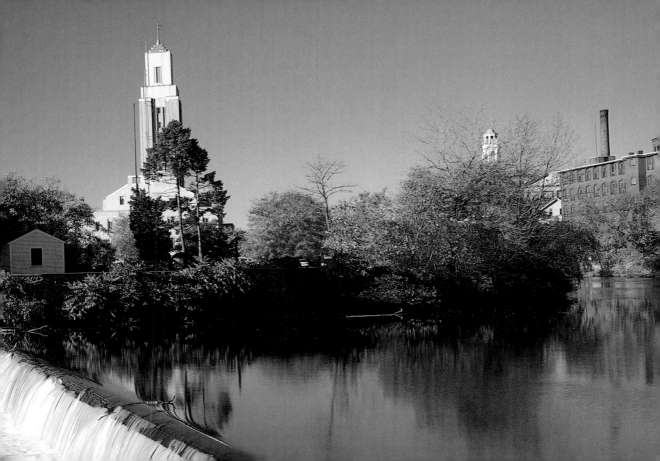

First published in the United States of America in 2003
by Rizzoli International Publications, Inc.
300 Park Avenue South, New York, NY 10010
www.rizzoliusa.com

Rizzoli editors: Jessica Fuller and Eva Prinz

Produced by Opto Design, Inc.
214 Sullivan Street, 6C, New York, NY 10012

Designers: John Klotnia and
Anne MacWilliams, Opto Design

ISBN: 0-8478-2668-6
Library of Congress Catalog Control Number: TK

2004 2005 2006 2007 2008 2009 / 10 9 8 7 6 5 4 3 2 1

Printed and bound in China

The deluxe edition of *These United States* is limited to
5,000 numbered copies, each of which includes a signed
and numbered print by photographer Jake Rajs.

ACKNOWLEDGMENTS
I would like to thank the following people for their kindness and
assistance in helping to make this book possible: Gil and Tama
Alfring; Bill Black; John Brancati; Carneros Creek Vineyard in
Napa, California; Willow Creek Ranch at the Hole-in-the-Wall,
Wyoming; Lydia Christoph; Walter Cronkite; Steve Dailey; Brad
and Mary Anne Gavin; Grant and Jane Golliher; Jim Good; Scott
Gordan and family; Charles Miers, Jessica Fuller, Eva Prinz,
Felix Gregorio, Rebecca Cremonese, Lou Bilka and Gena
Pearson at Rizzoli; John Klotnia, Anne MacWilliams at Opto
Design; JenMar Graphics; J. J. Jackson; Emily Lancaster; Jill and
Das Markus; Colleen and Doug Masters; Grant Parrish; Jerry
Paxton; Anne, Chloe, Olivia, Janina and Julius Rajs; the
Roasalsky family: Sara, Gregory, Alexandria, and memory of Sam;
Jules Solo; Mark Speed; Mary Steinbacher; Sandy Steinbacher;
Richard Stevens; Pat Swartz; Jimmy Winstead

DEDICATION
For my parents, whose vision of freedom brought us into this
country, and for my daughters, Chloe and Olivia, who represent
the future of the United States.

WE AMERICANS are a strange lot. When we travel abroad we seem to be overcome with embarrassment that our own country is so young. We put aside the pride we otherwise express in the success of this country of ours, which in less than two hundred years has become the shining example of democracy that most of the world's people would like to emulate. ☆ Instead, we stand before the Acropolis in Athens, the Coliseum in Rome, London's stately Houses of Parliament, St. Petersburg's grand palaces and we think of the monuments to our history as babes in swaddling clothes. ☆ Thus we desperately need the help of a photographer whose artistry has discovered the beauty of our history. ☆ Jake Rajs has found and glorified the profusion of landmarks that remind us of the American experience. Some are marked with monuments; others rest in their natural state. Individually they are not ignored. They are visited by crowds who experience them in awe and wonder and respectful silence or boisterous holiday hilarity. They can read from the bronze plaques and chiseled marble of the momentous events that occurred on the very spot. This is to our common heritage what to our family history is the search of graveyard stones for an ancestor's last resting-place. As the fading memorial carved in those stones bind us to our family, the monuments and battlefields tie us forever to our land. ☆ Many of our citizens are privileged to see some of it. Few are privileged to see it all. None has so captured its magnificent totality as has Jake Rajs. ☆ The mountains,

the plateaus, the escarpments, the wide prairies, the plunging waterfalls, the rock-ribbed coasts and the glorious beaches, the presence of living things—the galloping buffaloes, the marvel of our cities, the quaintness of our villages. This is the panorama of America. ☆ It is not the individual monuments but the grandness of their totality that Jake Rajs captures in this stunning book. He sees beauty in the steeples that mark the villages that once were colonial America, and in our cities the steeples glorifying commerce that we call skyscrapers. ☆ Here is the scope of our history, those sites where our laws were made, our philosophies honed, our battles won. The visitor can tread the very stone our ancestors walked or gawk at the bed where the hero slept and the desk where he wrote. ☆ It is the land itself that is our special historical inheritance. The very vastness of it is our glory and when we have the opportunity to enjoy it we gasp with its wonder. And then we get out our instant cameras and try to preserve the magic moment we have just enjoyed. ☆ Despite the vows inspired by those grand scenes, few of us dedicate the time to pursue the rainbow's trail to this continent's distant horizons. It is Jake's resolve and talent that turns an artist's search for the beauty of nature into the almost religious fervor of a pilgrimage. ☆ Jake has woven a stunning tapestry of the many threads of America. The tableau depicts our trials and tribulations and our success in overcoming them to become the shining example of human achievement that is these United States.

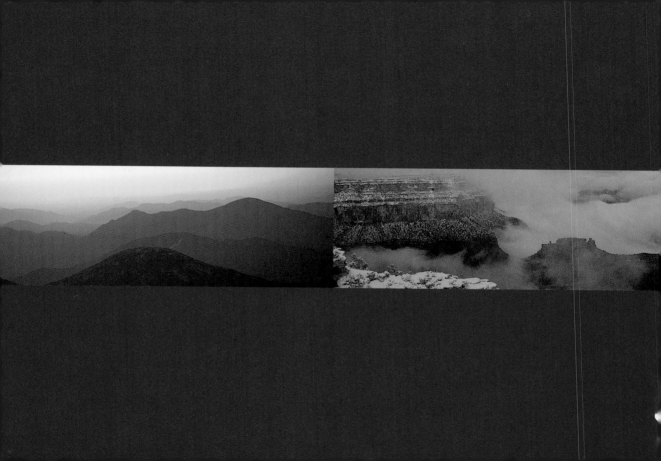

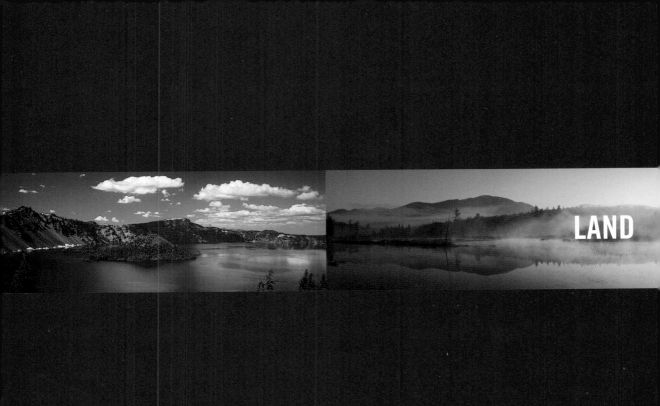

LAND

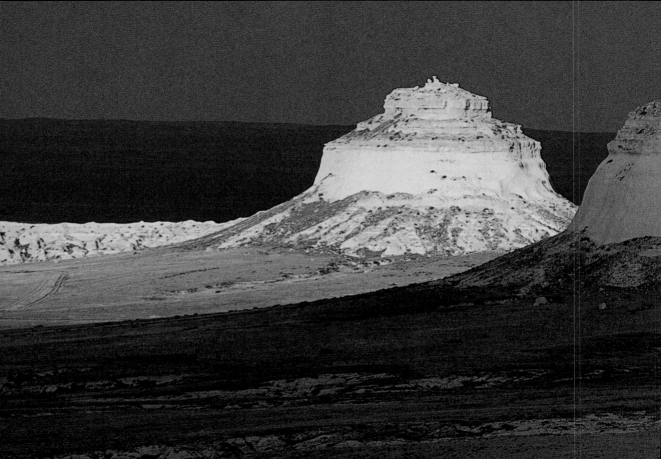

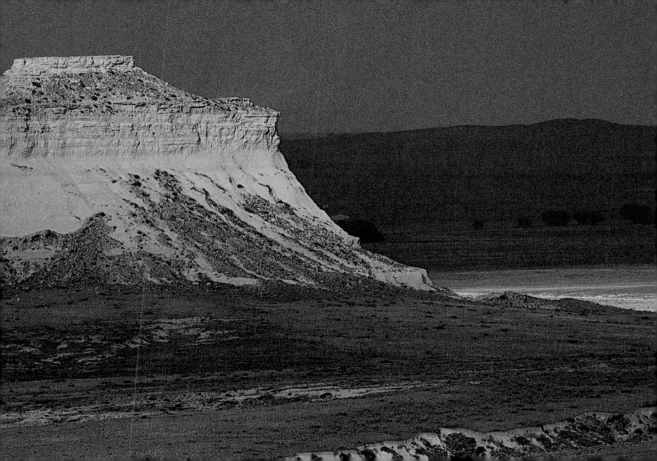

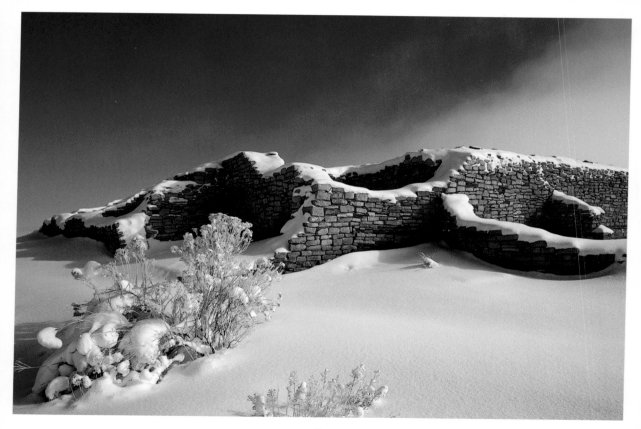

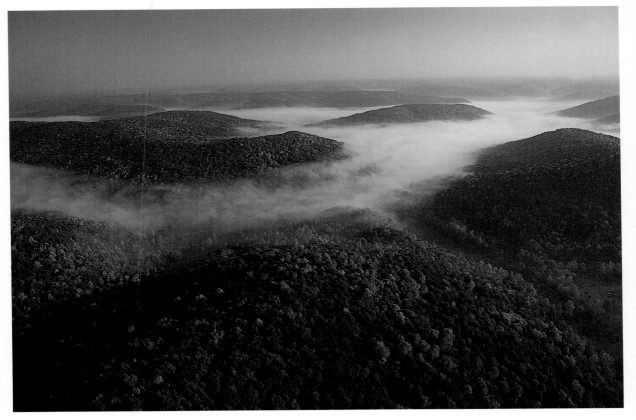

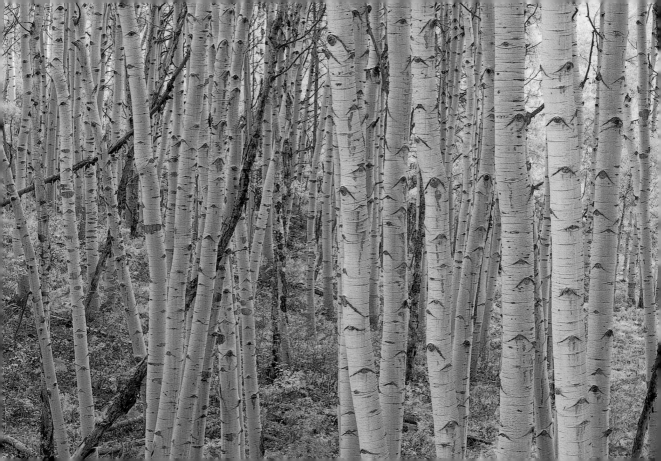

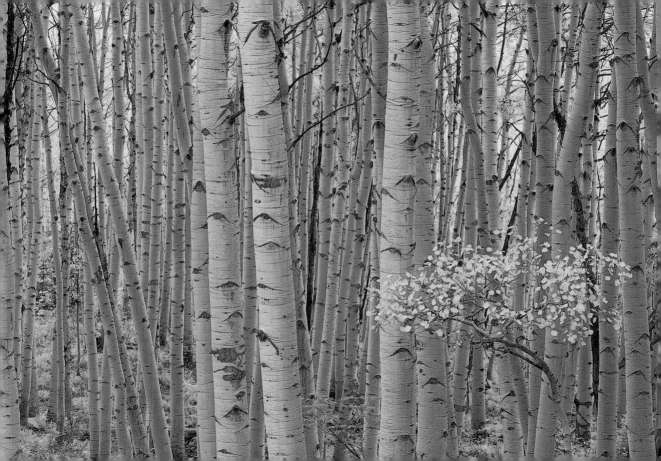

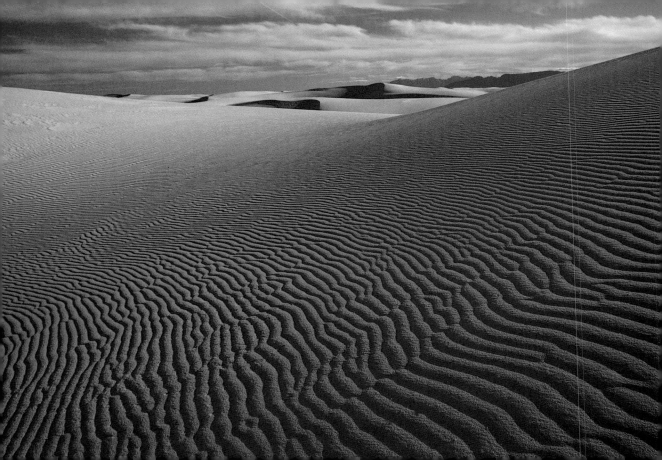

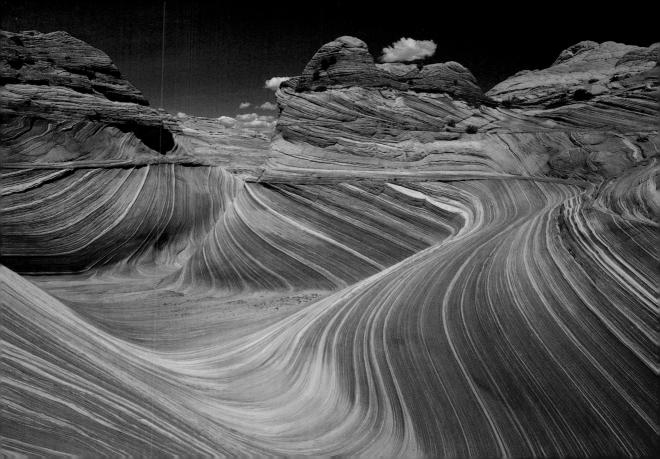

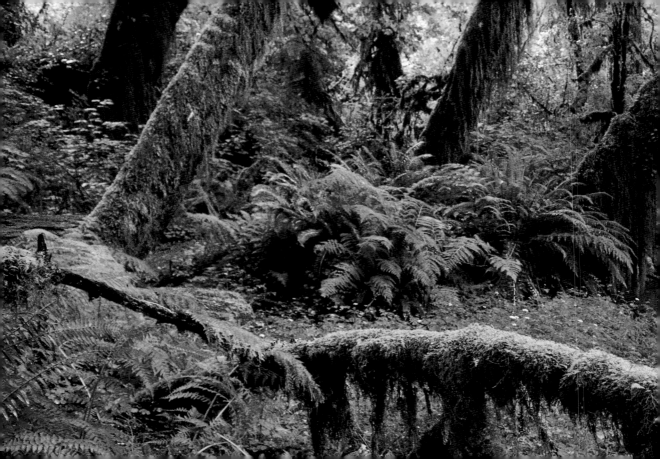

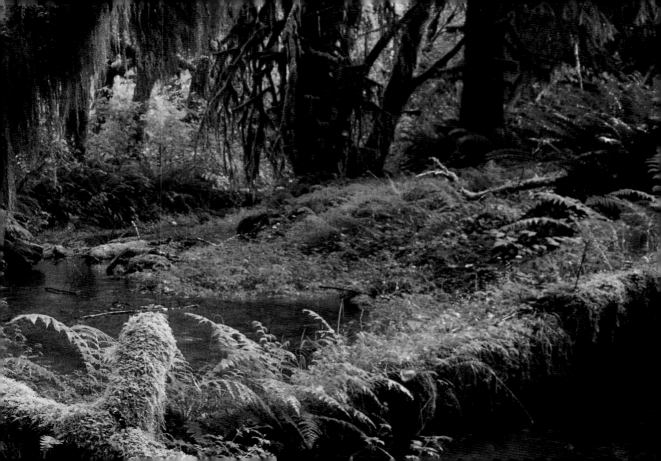

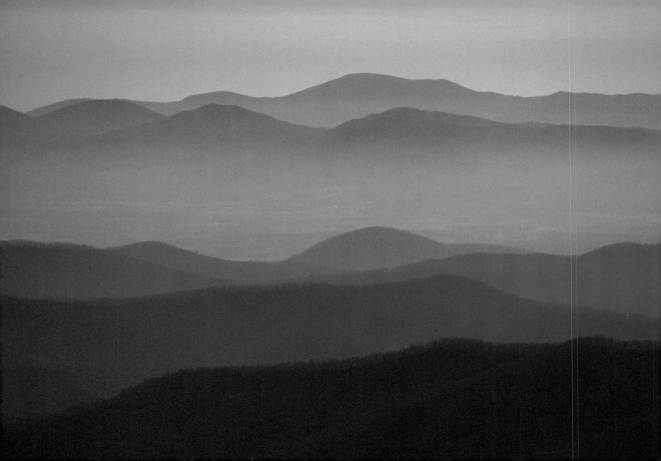

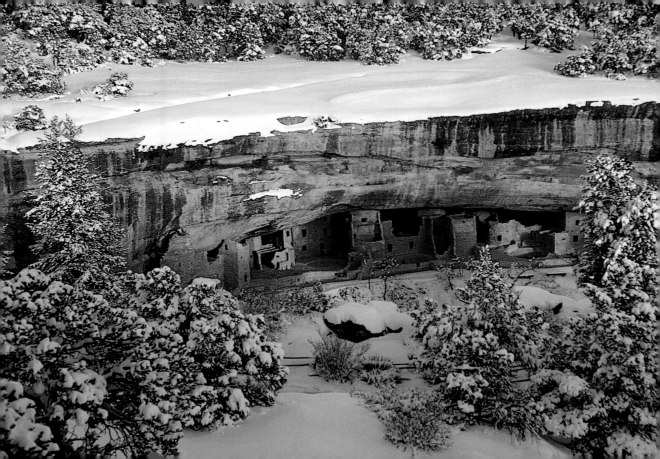

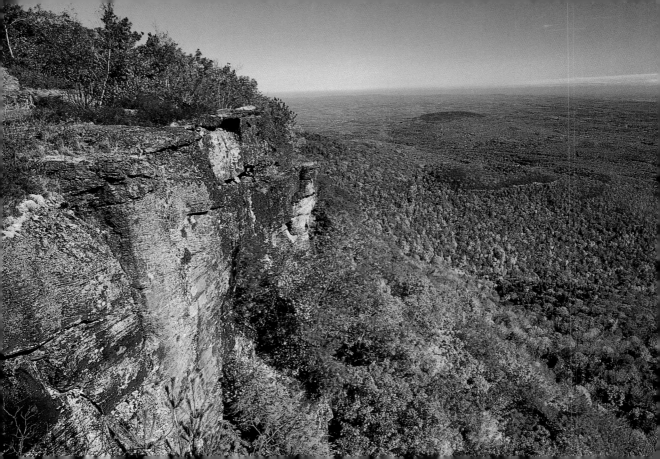

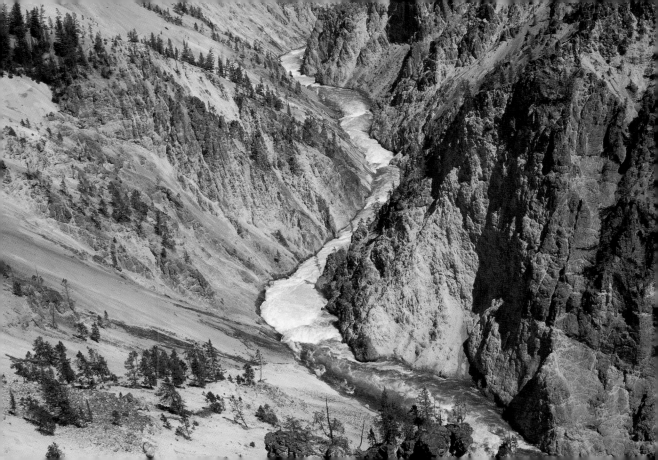

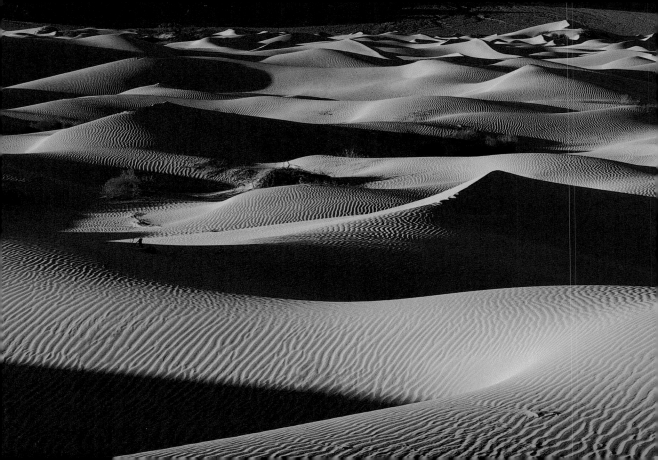

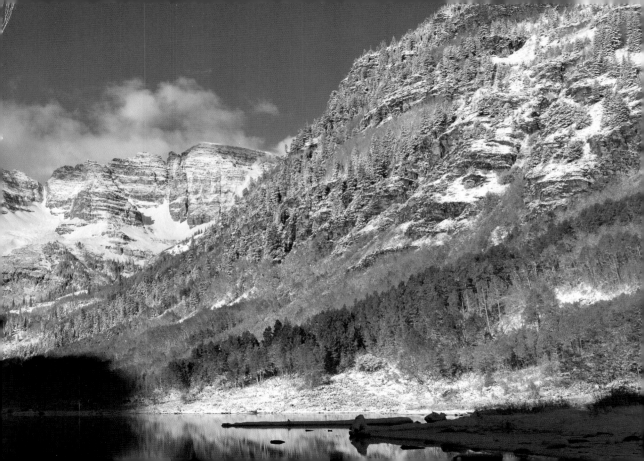

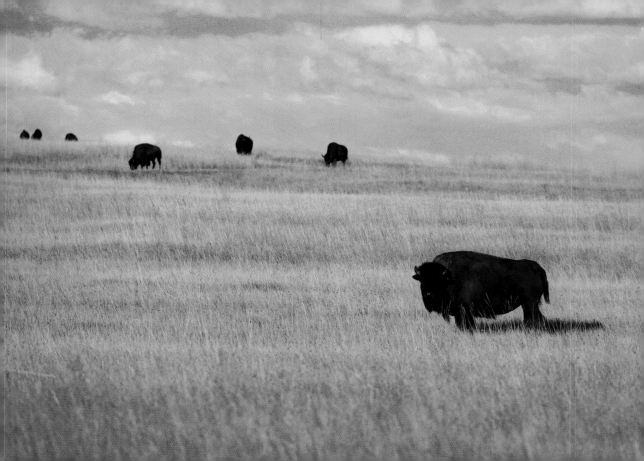

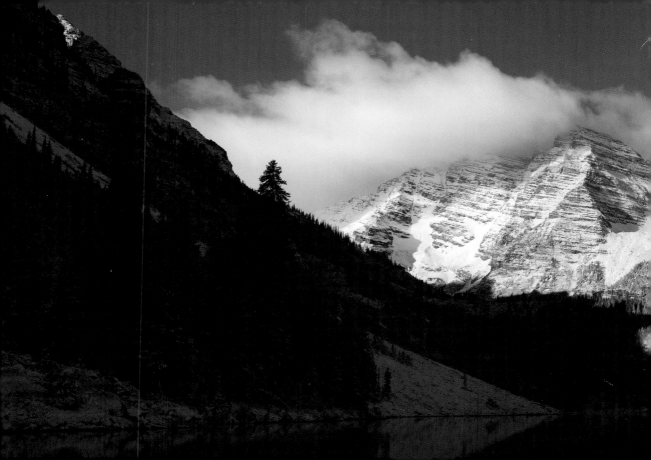

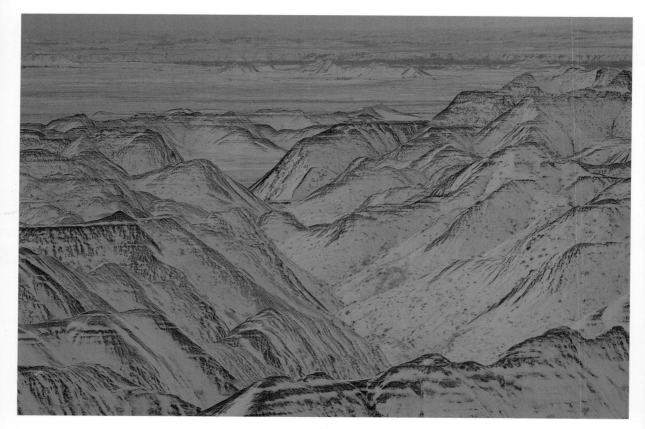

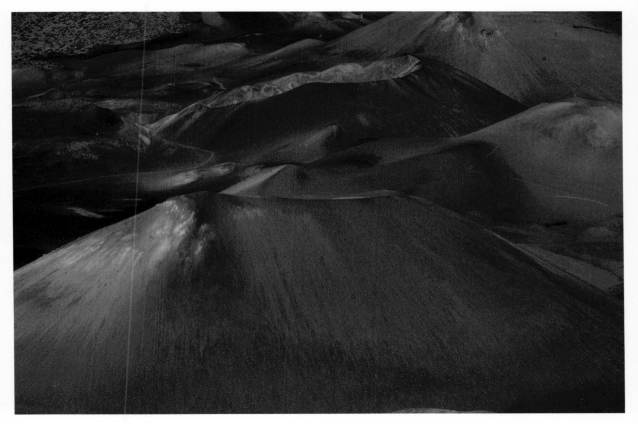

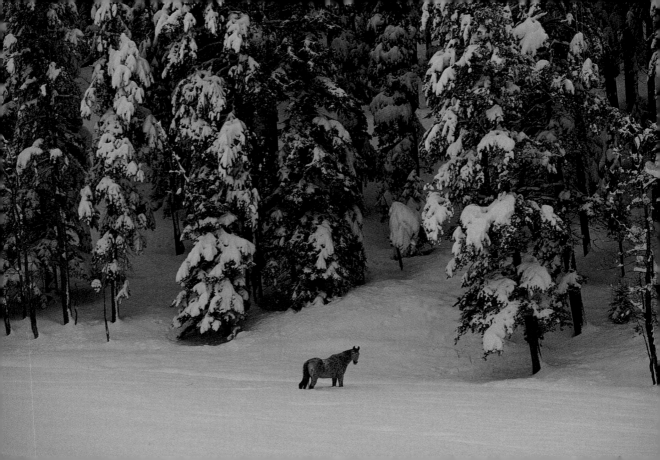

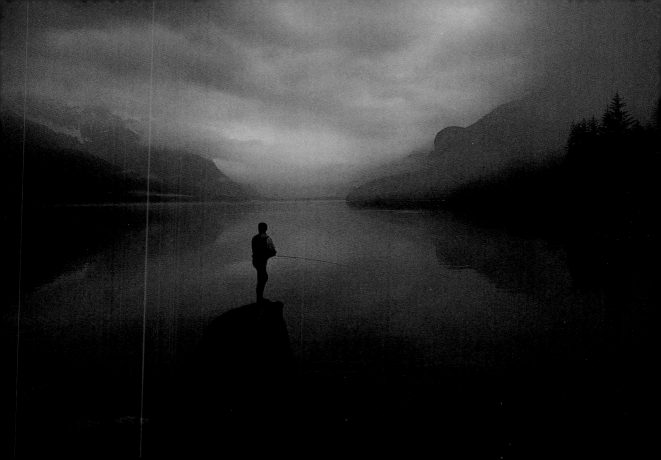

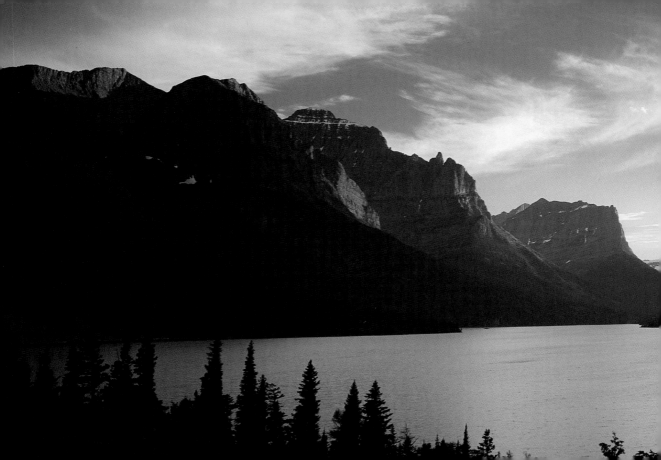

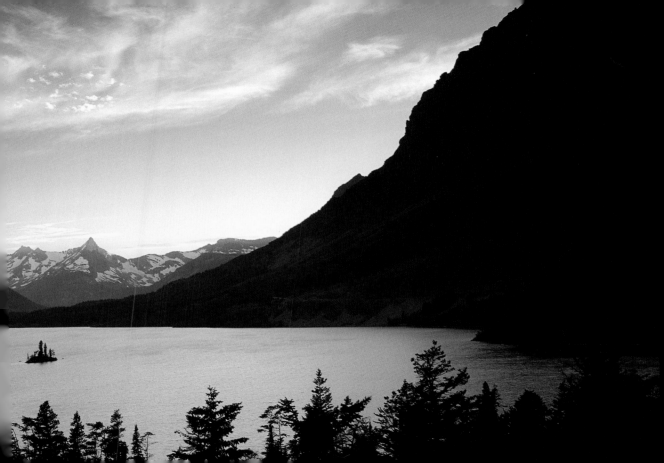

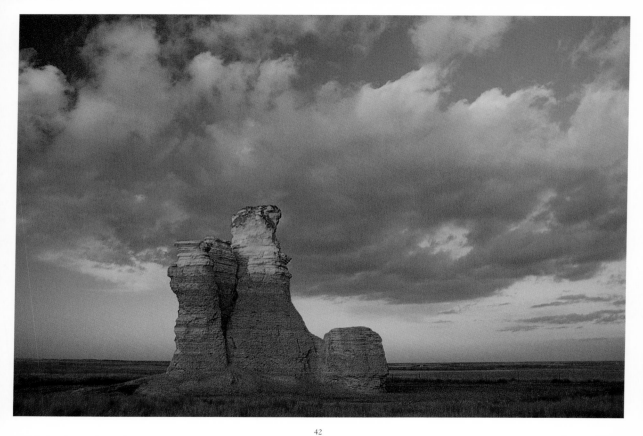

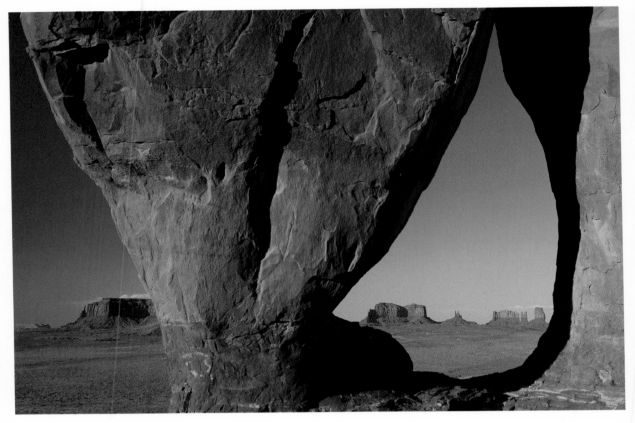

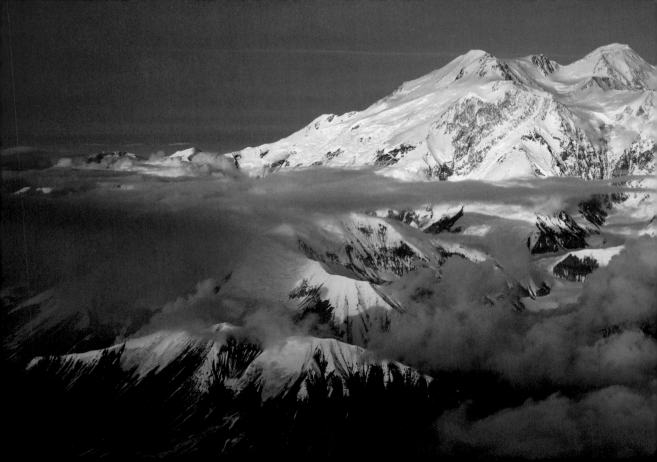

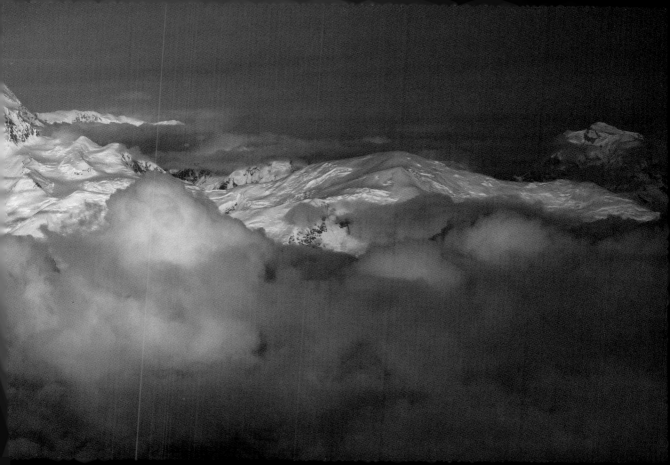

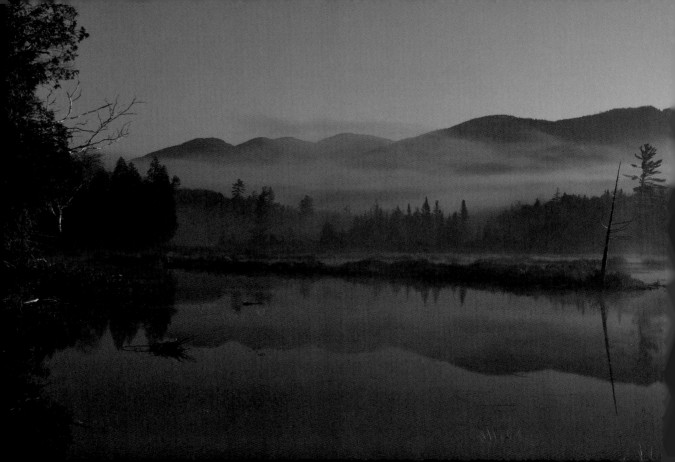

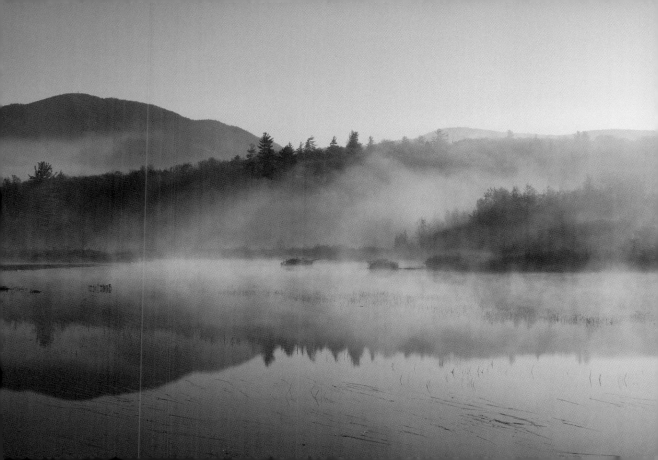

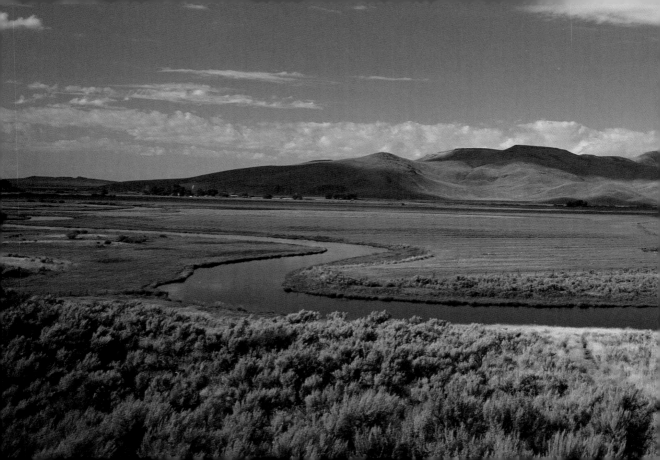

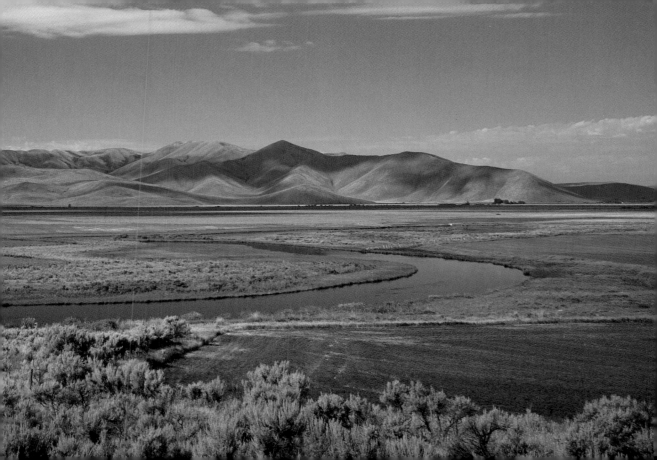

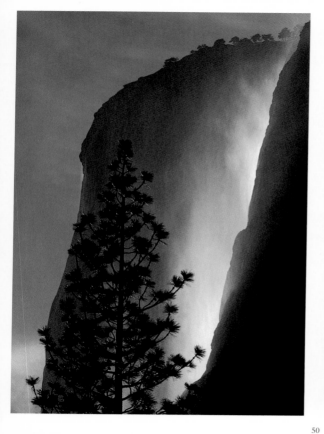

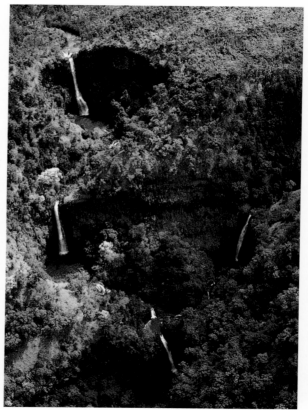

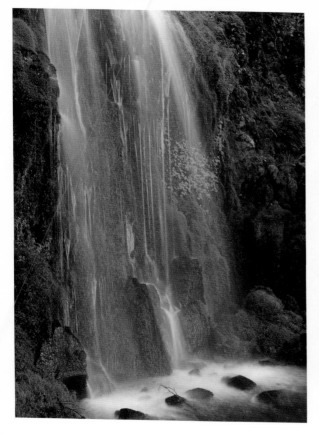

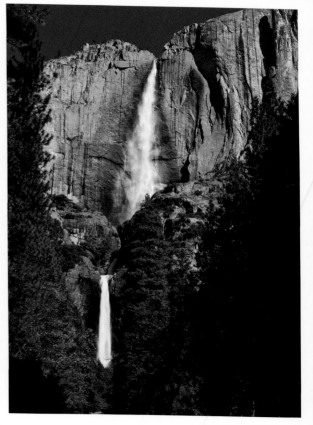

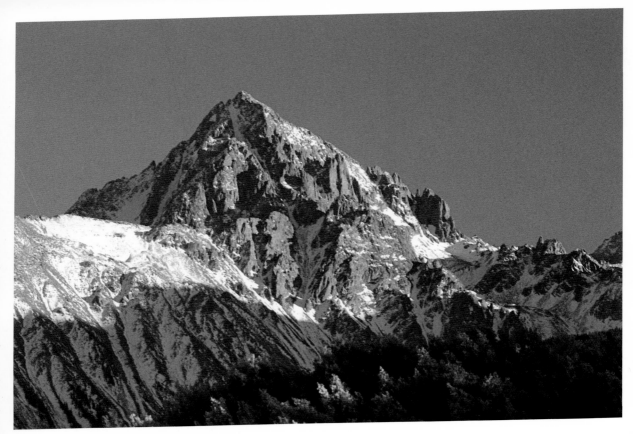

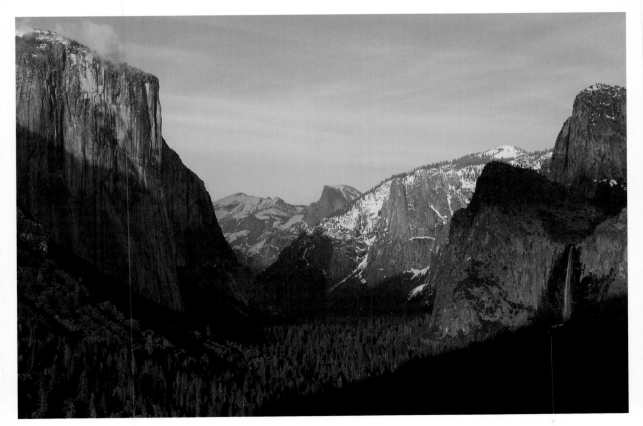

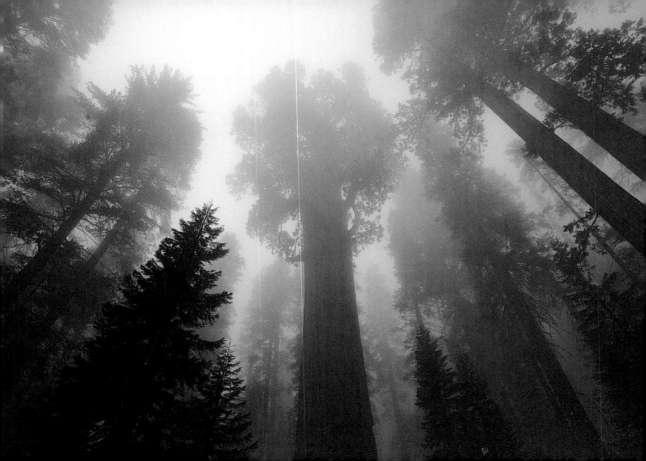

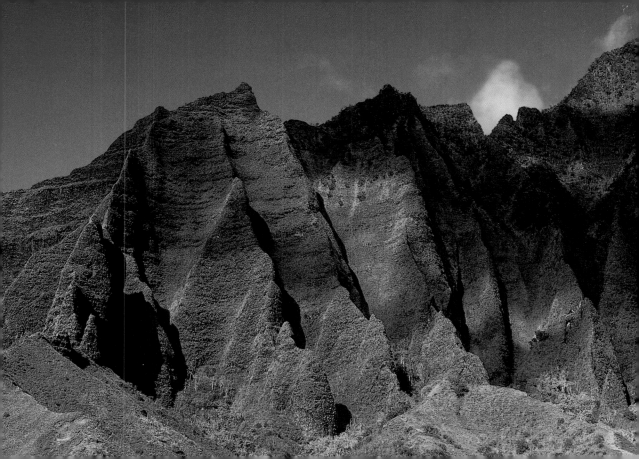

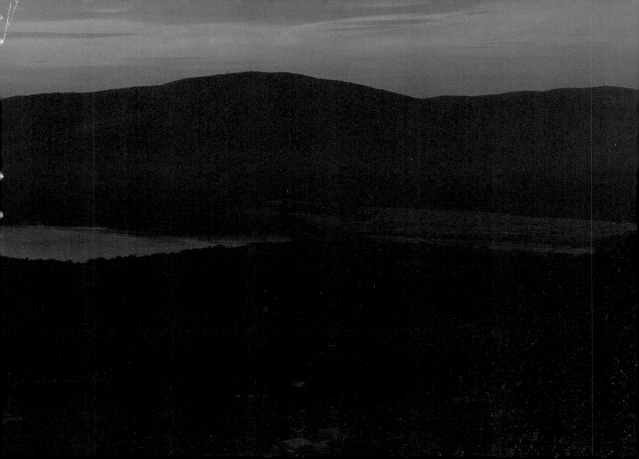

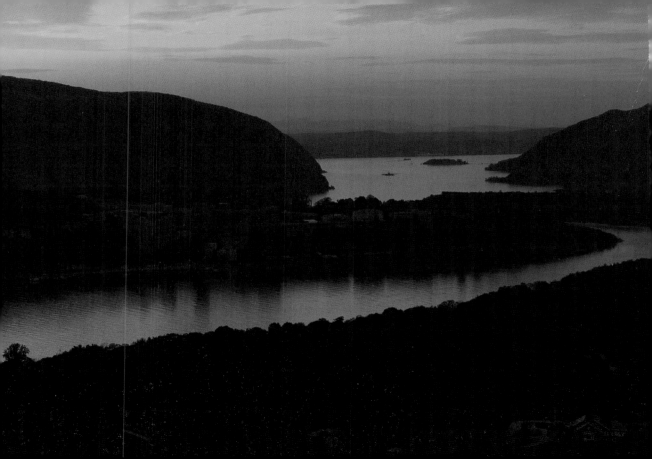

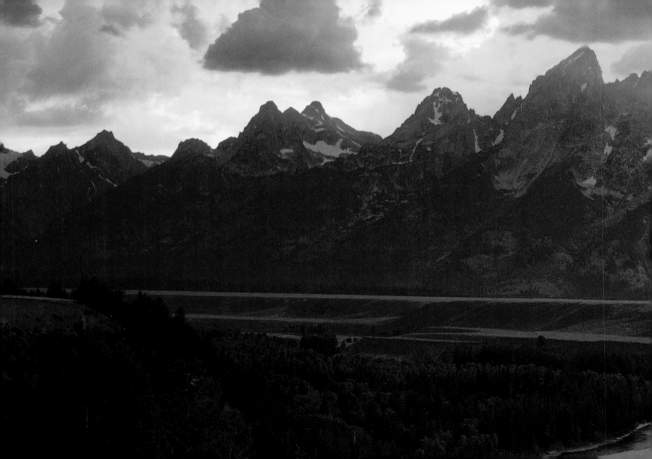

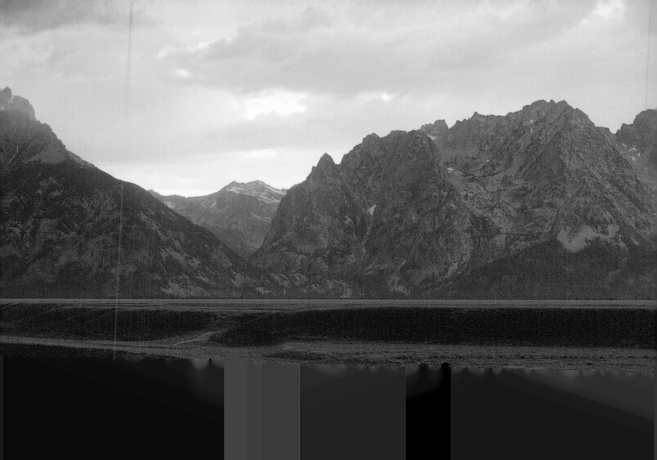

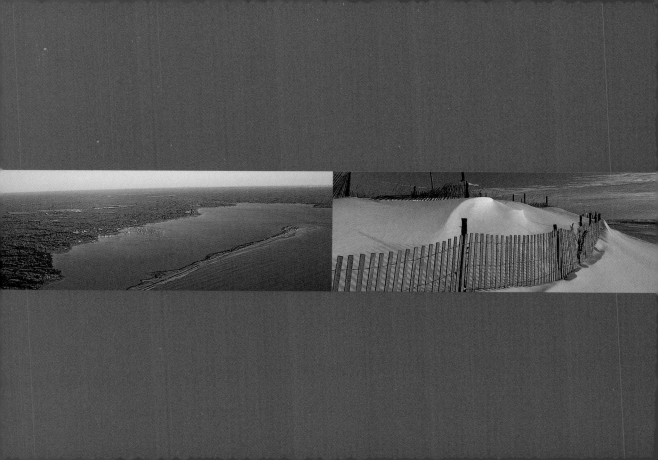

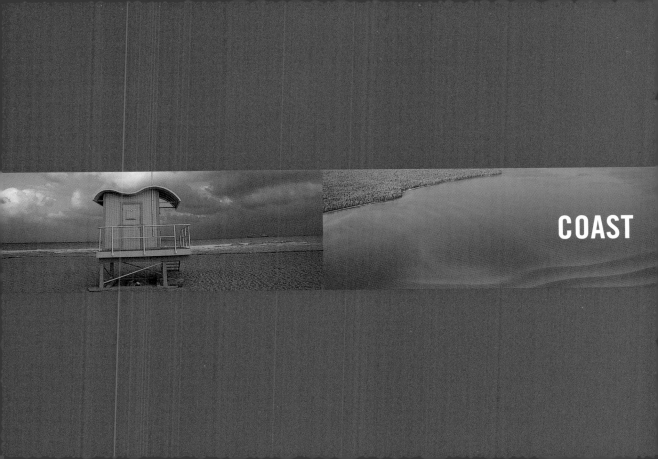

COAST

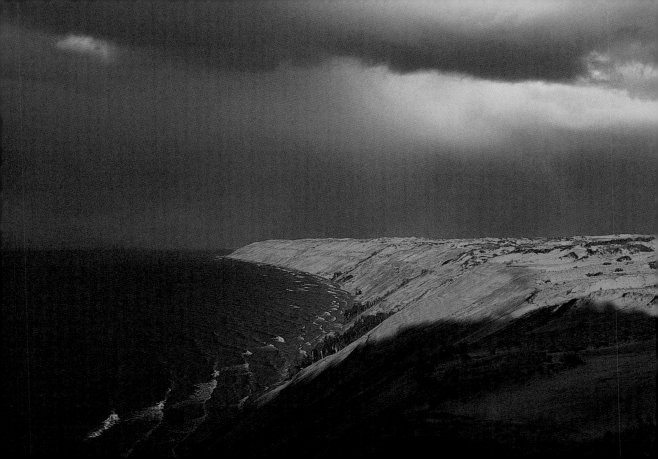

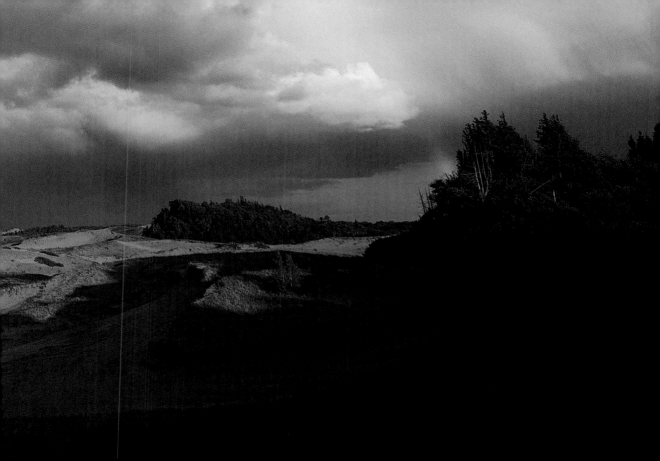

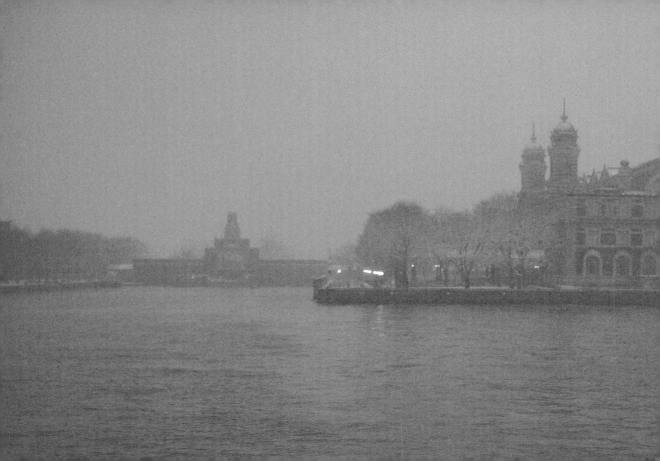

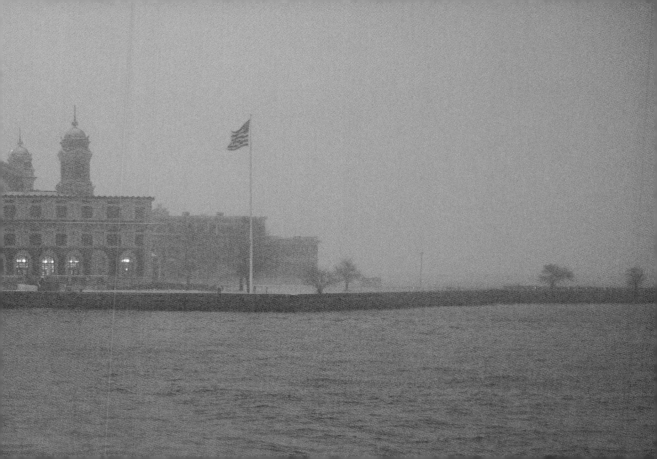

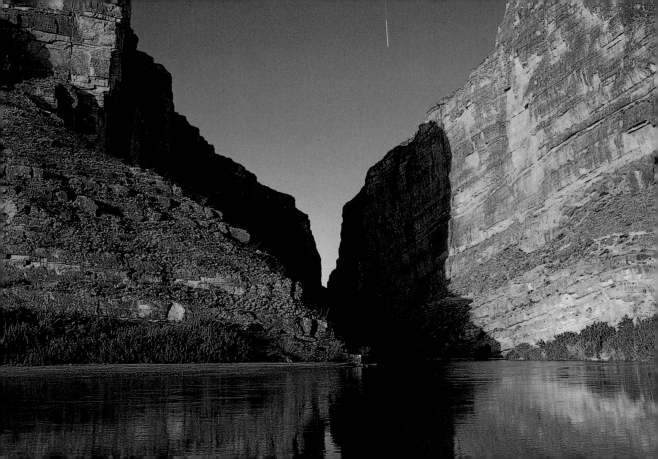

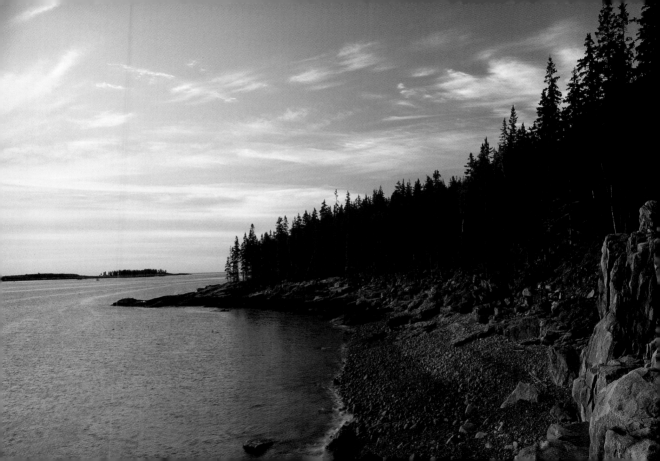

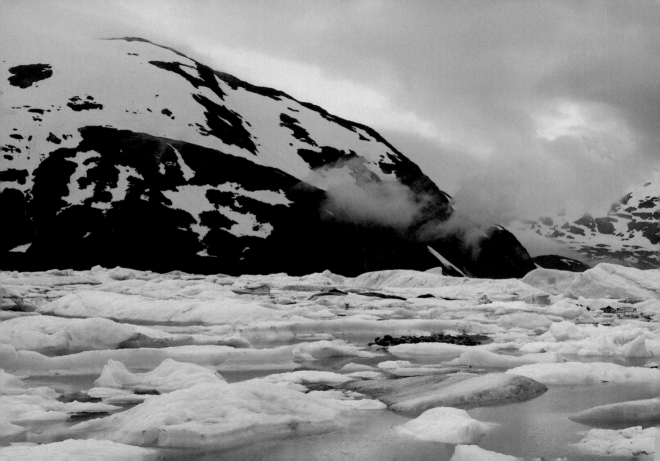

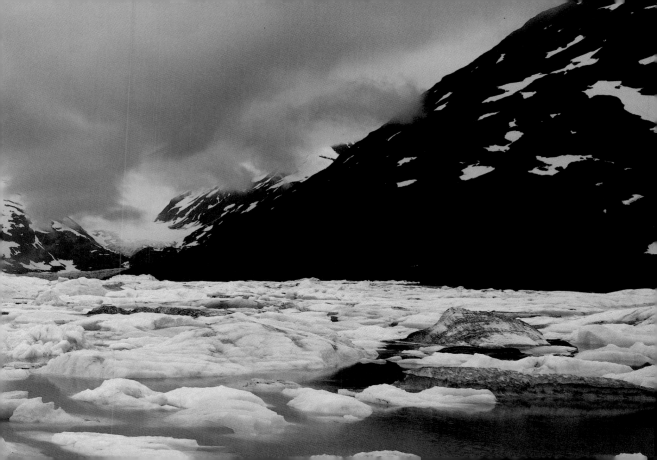

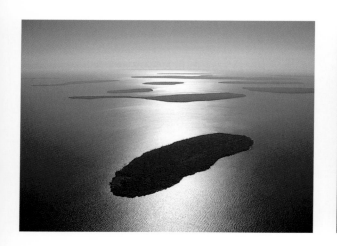

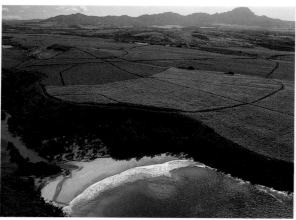

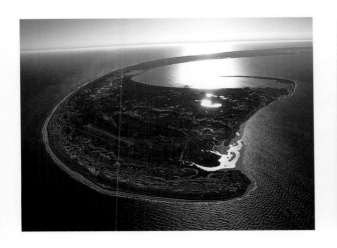

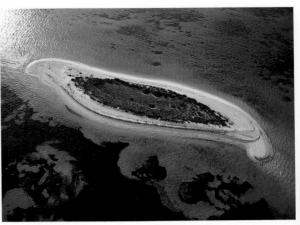

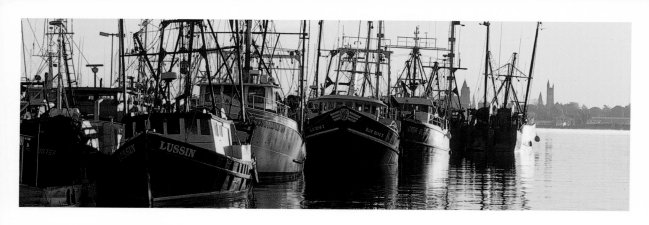

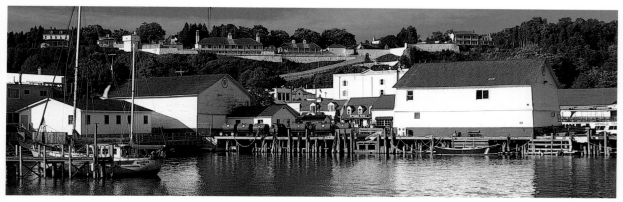

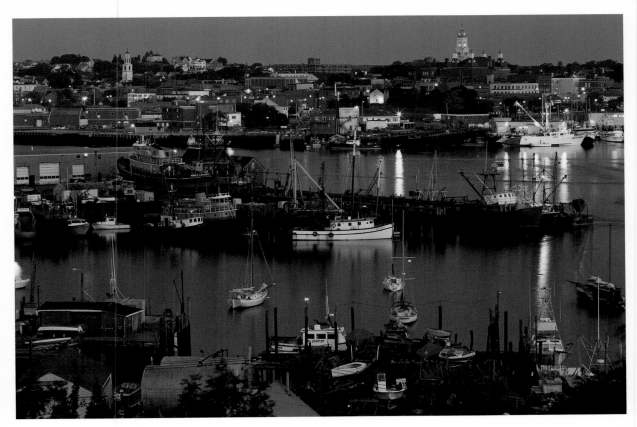

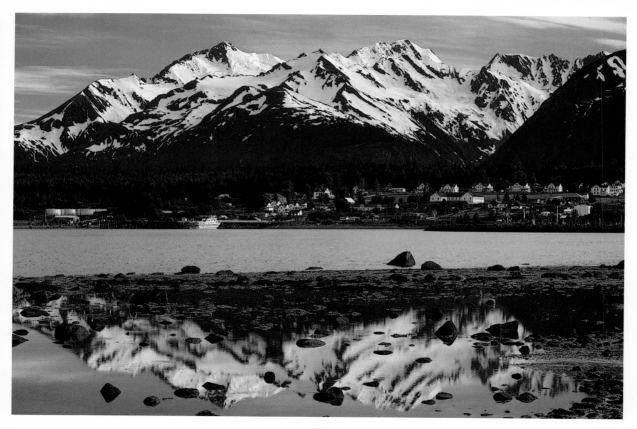

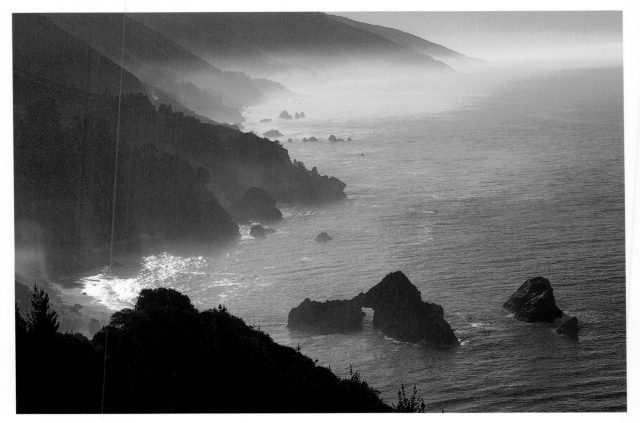

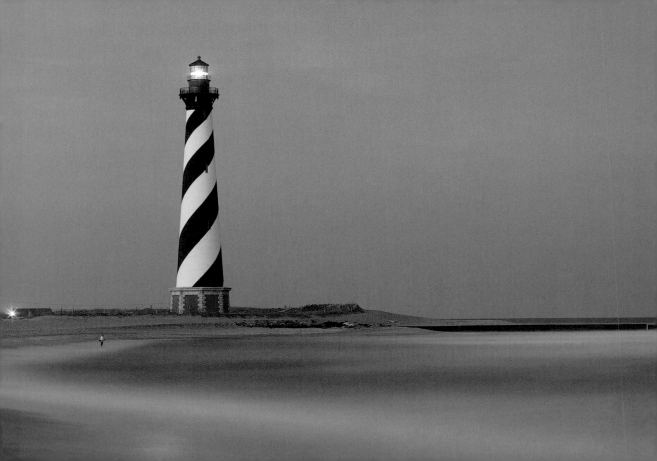

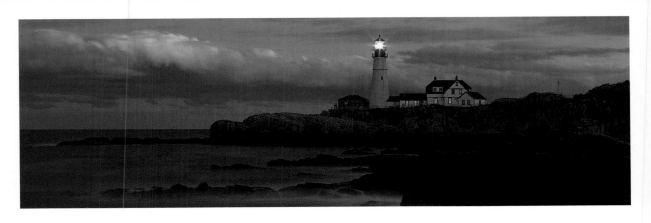

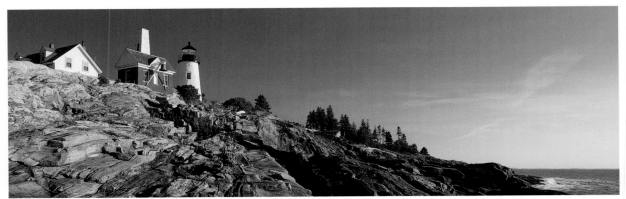

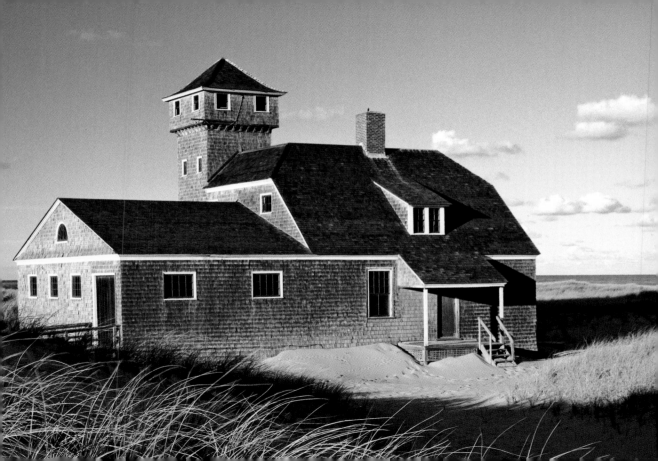

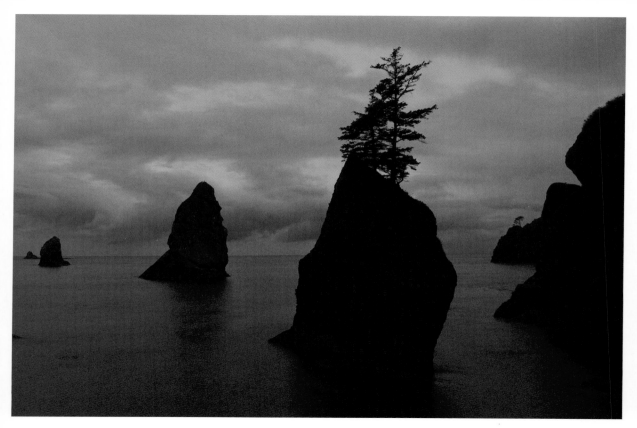

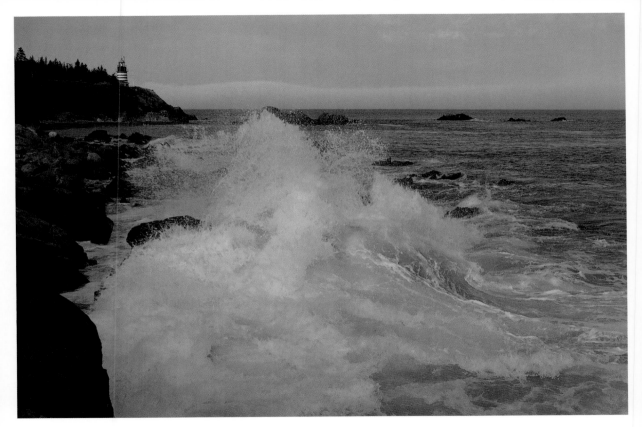

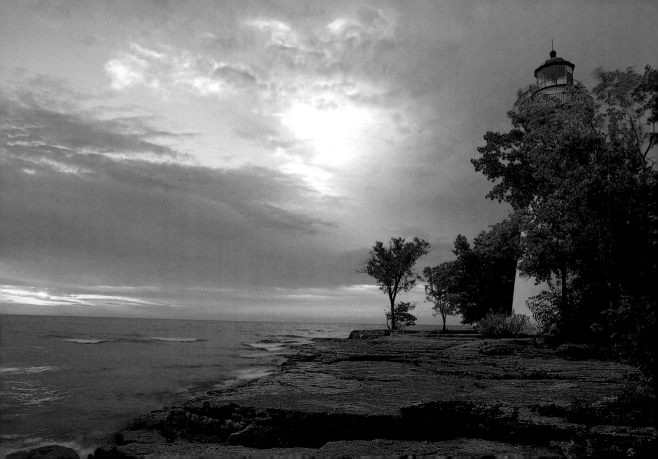

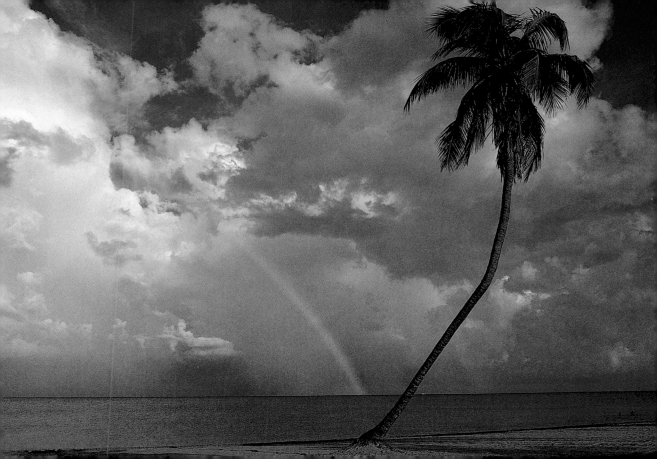

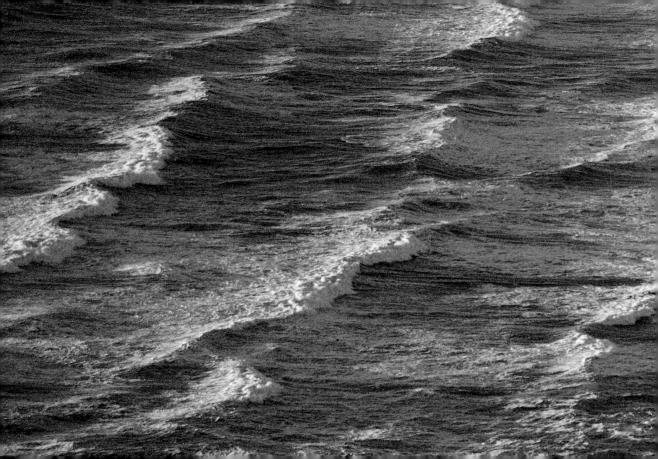

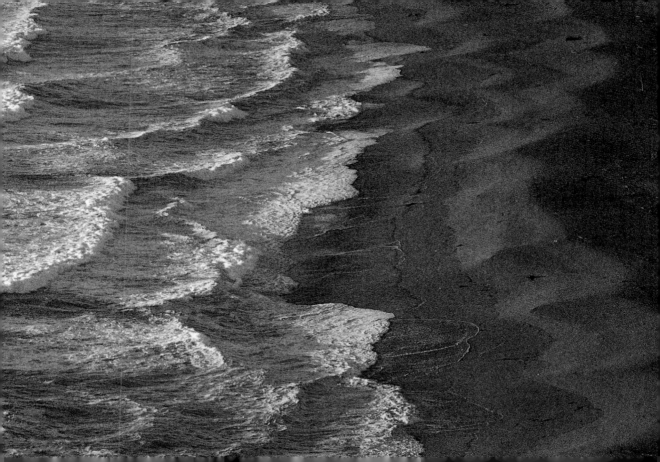

FREEDOM IS NOT FREE

FREEDOM

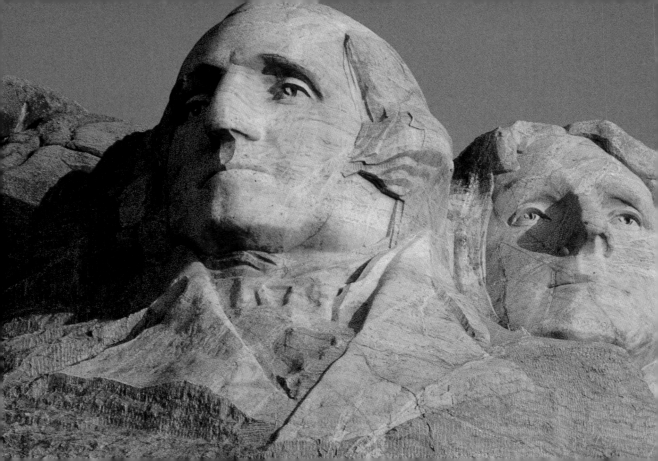

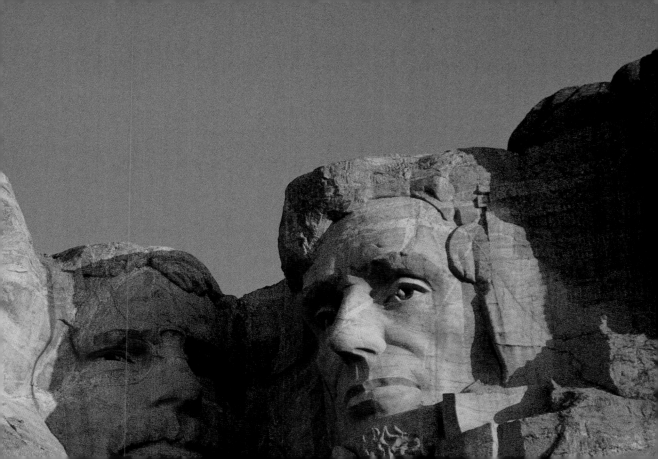

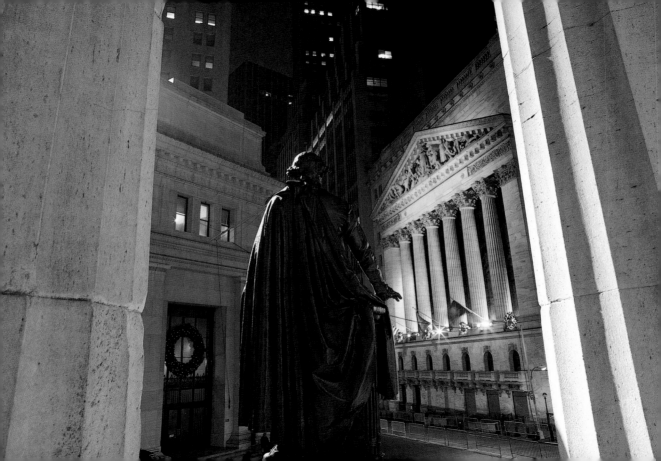

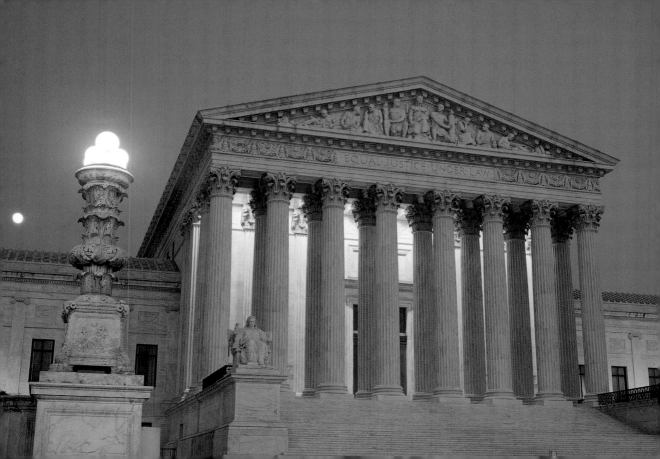

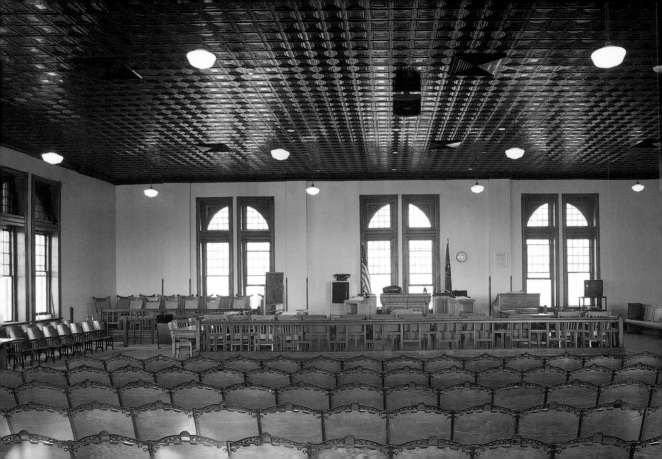

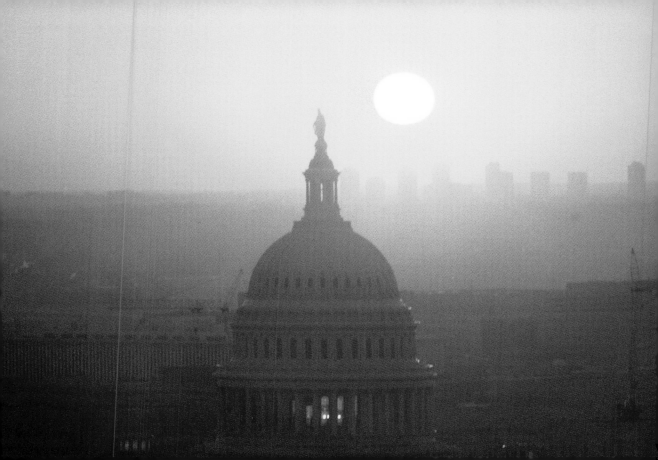

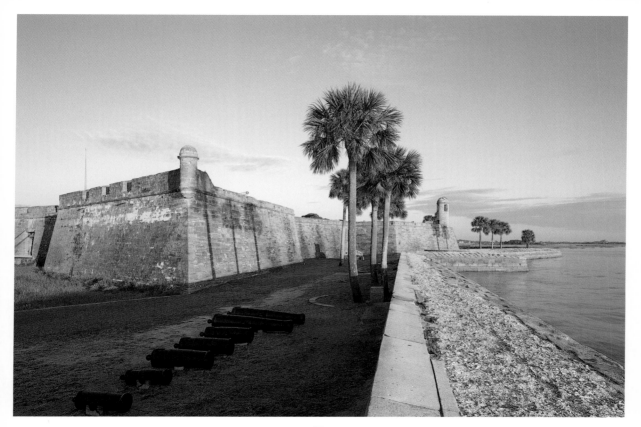

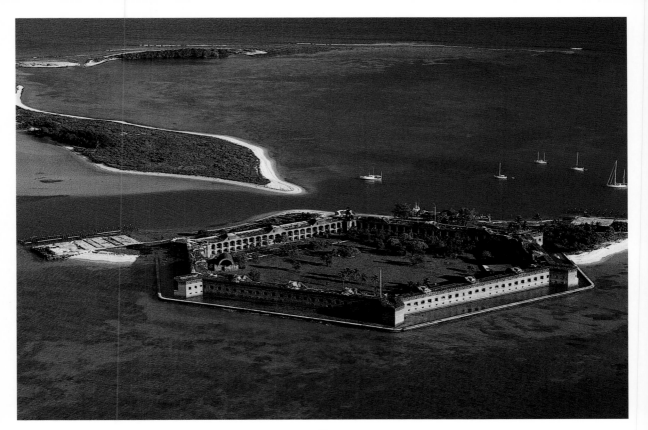

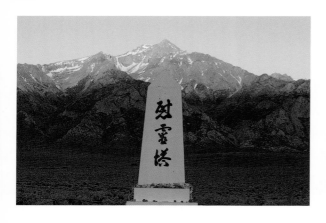

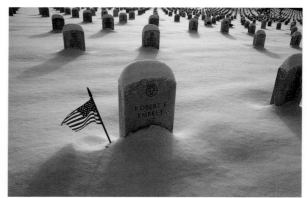

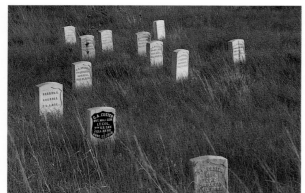

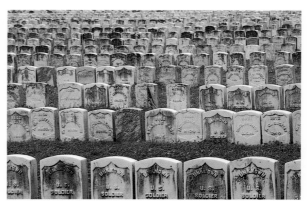

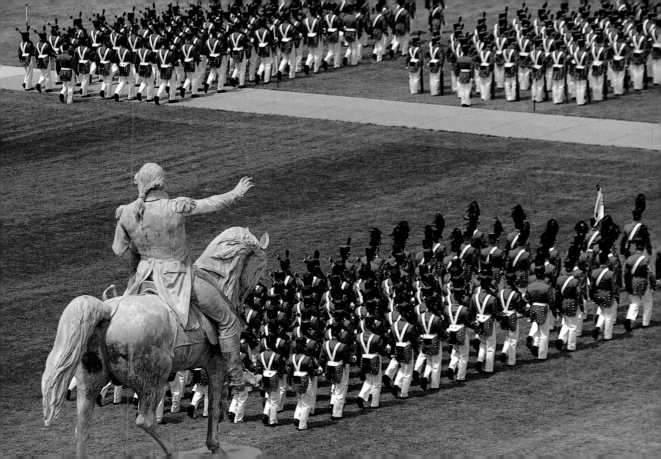

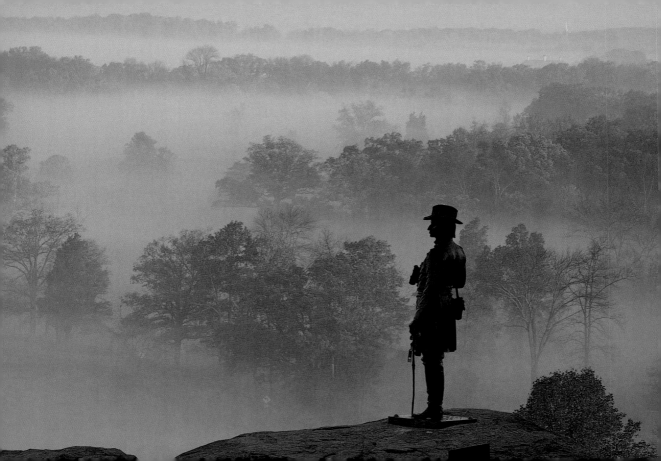

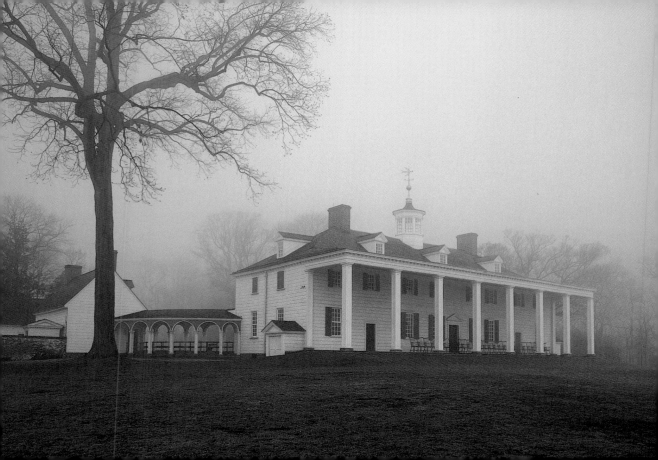

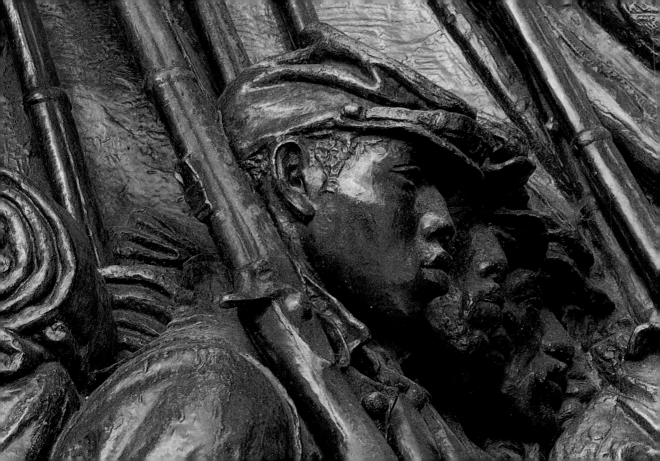

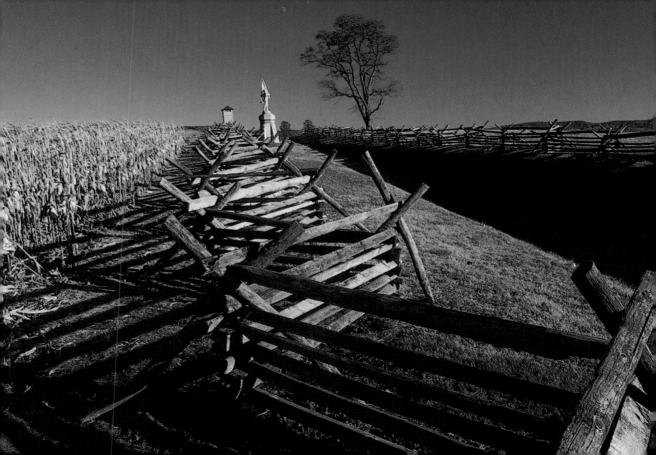

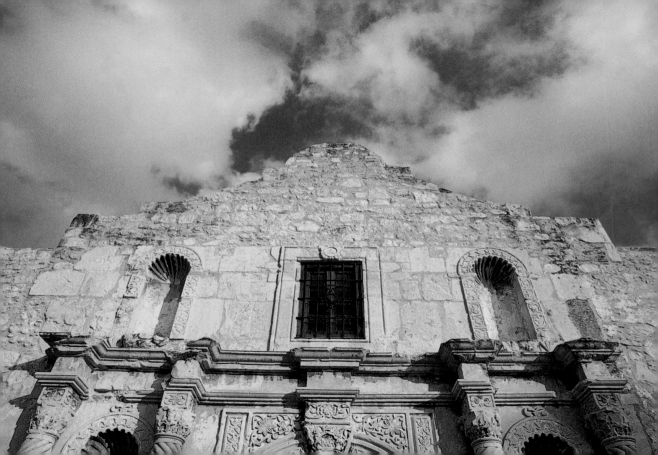

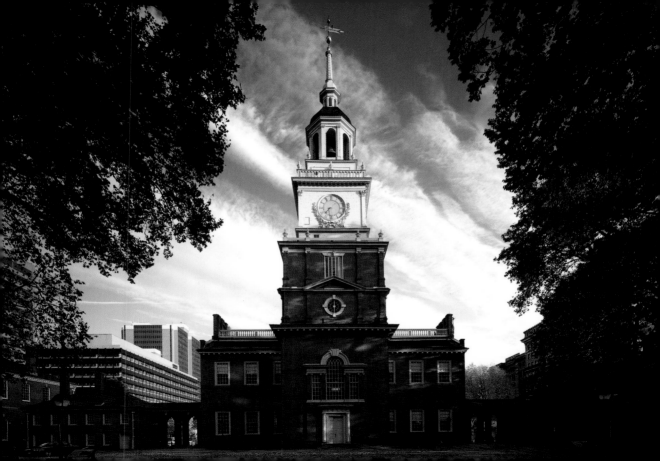

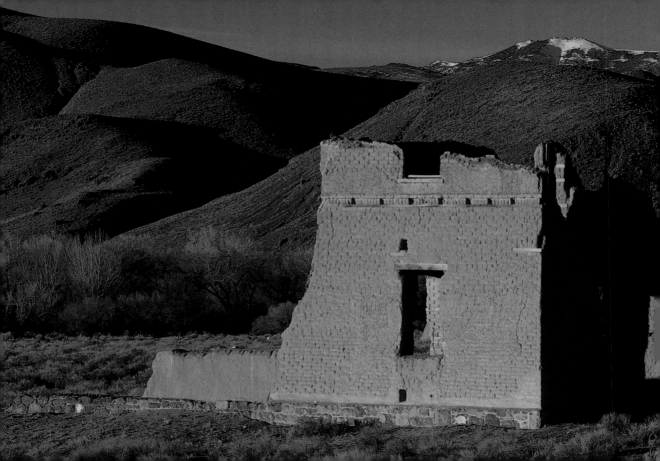

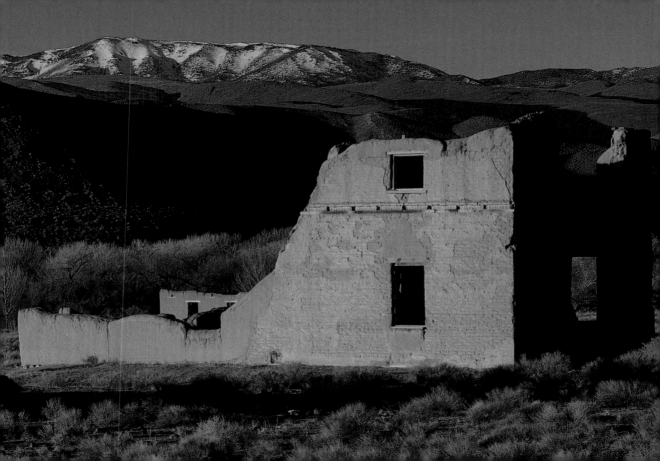

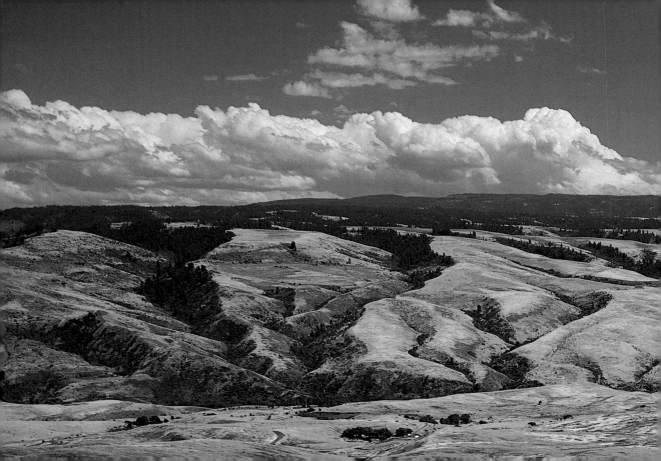

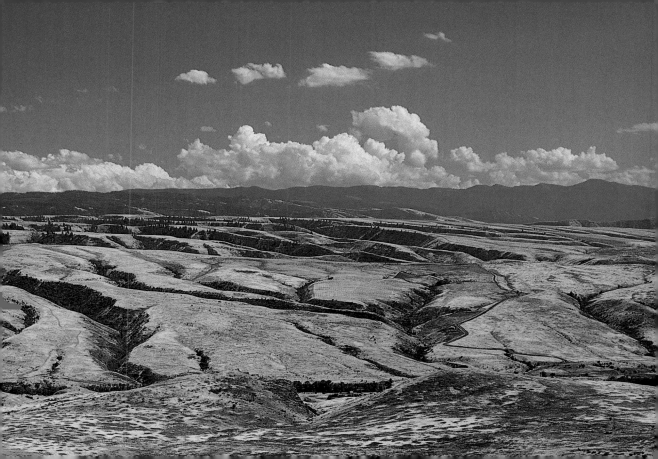

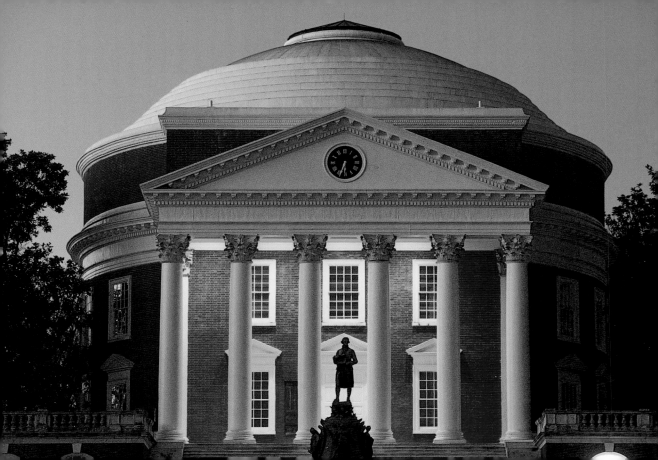

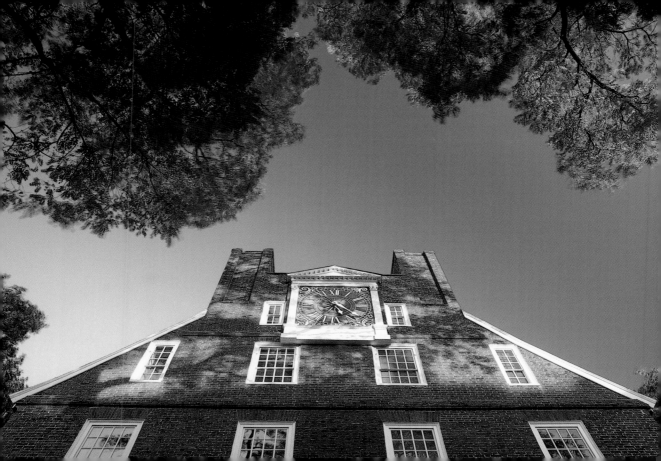

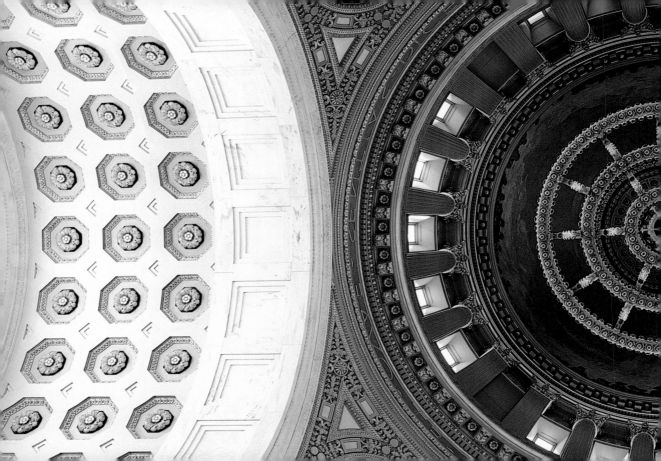

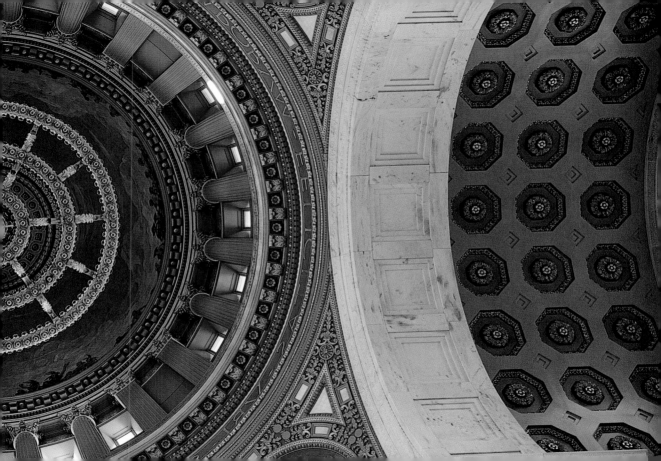

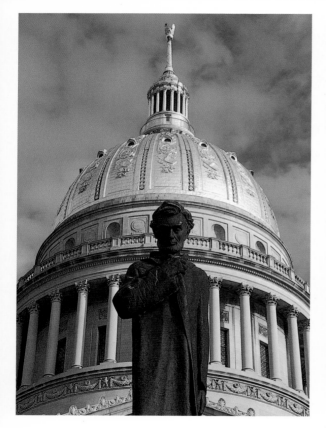

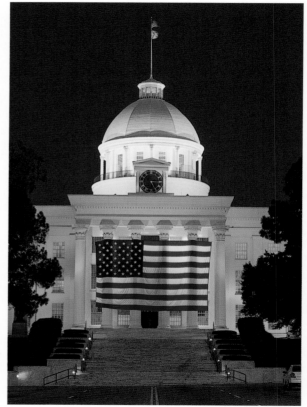

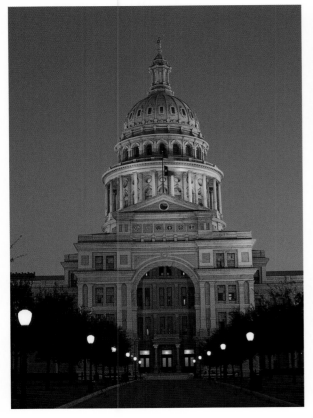
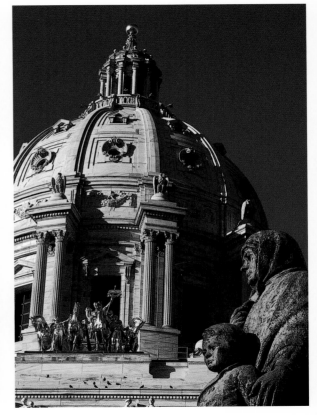

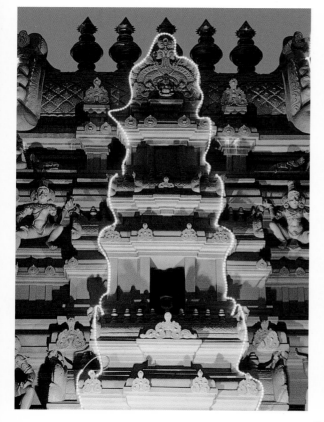

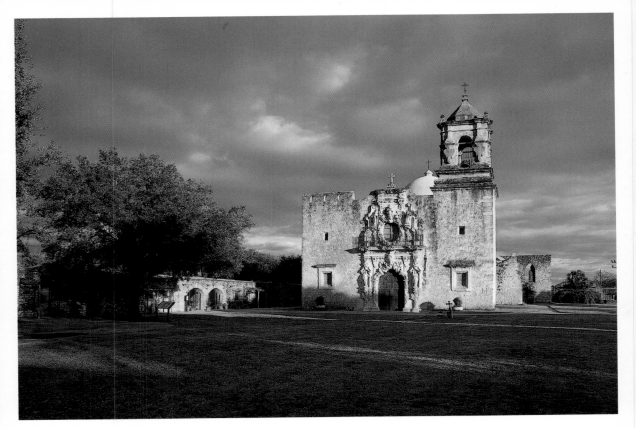

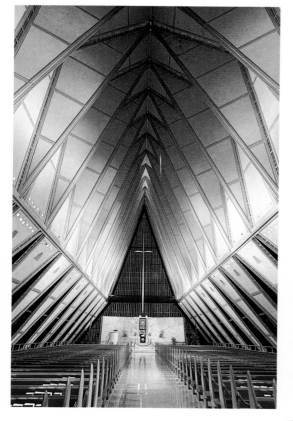

ROBERT H MARSDEN
KENNETH E LOVELACE
GEORGE R MARR
WILLIAM E MORGAN
WILLIAM J CARTER
JOHN M NEIL
GARNEY BURLESON Jr
HAROLD B LINEBERGER
BIRKY · JAMES P DUNCAN
D N JASINSKI · PAUL E LEE
WRIGHT · LARRY J PEPPER
HARRIS · LOREN D LEBEAU
RE · STEPHEN E WARREN
OWAN · ROBERT E TAYLOR
R · PHILIPP R VOLLHARDT
RNE · THOMAS A MRAVAC
ON · ROBERT J WILLIAMS
SHALL · DANIEL J MULLEN
NOR · PATRICK J TROTTER
PAUL · DAVID A SEMMLER
KENNETH W BONESTROO
J KERL · CARROLL R MILLS
S · THEODORE R MASON
A LARGENT · GARY LEWIS
DOUGLAS R SCHMALTZ
ON · HARRY WOLFENDEN
DLY · BARRY L BRINEGAR
FOX · ROBERT B GENTRY
EYER Jr · JOSEPH W MILEY
JOHNNY MACK TINNEY
NSLEY · DANIEL F FARRELL
VELL · JAMES A McINTYRE
AKE D WHITNEY
RAIMEY

DAVID O SCHARREN · SANTOS · ROBERT W PEOPLES
THOMAS P McMAHON
STEPHEN RICHARD E RAMEZ
THOMAS E TESTORFF · WILLIAM D SCHLUETER · HARRY C LEWIS
RICHARD W FORD · RUSSELL G AHRENS · BOBBY G HARRIS
THOMAS M KENNEDY · CAESAR MURRAY · GENE R KENNEDY
WILLIAM P BEARDSLEY · FREDRICK J CRISTMAN
JOHN D MARAU · JOHN T CHUBB · DENNIS R KENNEDY
VERNON G T KINGSLEY · MICHAEL E KOSCH
MICHAEL L WOODARD · F McFARLAND
REGINALD J ABERNETHY · BILLIE JAYE MARLING
BENJAMIN W DUNCAN · WILLIAM H FELS · CHRISTOPHER
MICHAEL J HARRIS · DAVID R HAYWARD
ROBERT N LEBRUN · CHARLIE M LOGAN · PETER
CLARENCE M SUCCTION · JOHN G TRAVER III
PAUL FOTI
DONALD K OSBORN · JEFFERY L QUINTANILLA
MANASSEH W DOUGLAS FAVORS · CURTIS D BAUER · HARRY M BECWITH III
JEROME D KLEIN · LARRABEE · JOHN C MERRITT · WILLIAM E NEAL
RONALD F YALE · THOMAS C SHEPHERD Sr · WILLIAM D SMITH · GREGORY M STONE
ROBERT D WALTERS · ARTHUR WILSON Jr · MICHAEL D WRIGHT · BERNARDO KEALOHA RAMOS
EDWIN G CALHOUN · CHRIS BROWN Jr · MAXIMINO ESTRADA · DOYLE FOSTER · GARY G GEIGER
GARY D HALLIDAY · GEORGE THOMPSON · OLIN D MARLAR III · R D McDONELL
ROBERT L WUNDER · RICHARD J ROSSANO · LARRY A IMONSON · JEROME E JACKSON · RANDALL A THOMPSON
DENNIS L WASZKIEWICZ · MANUEL RAMIREZ PUESTES · JACOB B BABIN Jr · ROBERT COFFEY
JOEL R HAWKINS MARTIN · WILLIAM A KINDER · VINCE R KISELEWSKI · DEAN W KRIEGER
DAVID RAMIREZ MENDOZA · LAWRENCE PHILLIPS · JAMES M RISCH · GARY A SCHULTZ · GORDON C CHILDSON
ALBERT A VENCH OTTO W BEN · GERALD ZLOTORZYNSKI · THOMAS P OLSON · PAUL E SERIES · GLEN H NEFF
ARTHUR L GALLOWAY Jr · WILLIE JOHNSON Jr · DONALD C BENNETT · VICTOR R BENNETT
MICHAEL L BAYNE · RONALD J BECKSTED · CLIFFORD W CORP · HARRY D AUSTIN
MICHAEL L CROSS · MICHAEL L BOND · RICHARD R CARSON · CLIFFORD W KNIGHT · JOHN LINCOLN
RICHARD J BOEHM · DAVID EDGEMON · KYLE S HAMILTON · RICHARD V KNIGHT · STEVEN D PLATH
WILBERT S GILBERT · JAMES B JOHNSON · WILLIAM M KIRKPATRICK · LAYMON PALMER · PAUL A SHEER
MICHAEL S HOLLOWAY · MYRON E JOHNSON · CARL B McGEE · LARRY W McKEE · DALLAS D ROBINSON · ROGER D WHITLOW
WILLIAM F MILLER · WARREN P RITSEMA · DONALD M STOTTS · MICHAEL J FRANKEL
TERRY L PRITCHETT · JOSEPH R RYAN Jr · DONALD M ERICKSON · BARRY A NASH
TERRY J PRICE · CLARY CHARLES H EDWARDS Jr · ROGER A BOSWORTH · DAVID F NOEL
ROBERT J SCHUMACHER · TERREL O NIMBER · LESTER J NOE · ALLEN E KINSMAN
RUSSELL E CLARK · CRAWFORD H TRAVER · AMADO ALANIZ · MICHAEL J MYERS
THOMAS A BROWN III · RONALD CLEVELAND · MICHAEL A WADE · FRANCO V JAMES
RICHARD H RATLIFF · ROBERT J SKEWES · RANDOLPH L MARTIN · GUS C OSHANASY
RICHARD L STANSBARGER · THOMAS H RATLIFF · ROBERT LEE · JAMES SALLES Jr · JOHN T N ANDERS
TERRY LEE BOSWORTH · RAPHAEL J COLLAZO · ROGER G REID · HARRIS L THOMAS
GARY LYNN PACE · BILLY RAY PARNELL · MICHAEL L THOMPKINS · TERRENCE C WRAY · JOSEPH W JO AGERMAN
DONALD R BAILEY · ARTHUR HERNANDEZ · GEORGE H YOUNGERMAN · ALFRED J THOMPSON
MICHAEL S McPHERRON · PHILIP B TERRILL · DONALD J HAVEL · STEVEN C WRAY · HOWARD J BRINGTON
D DAVIS · DONALD LEE · JAMES F PETERSON · WAYNE R BOROWSKI
PETER L WINTER · DENNIS KAISER · ANNE L A WASHINGTON

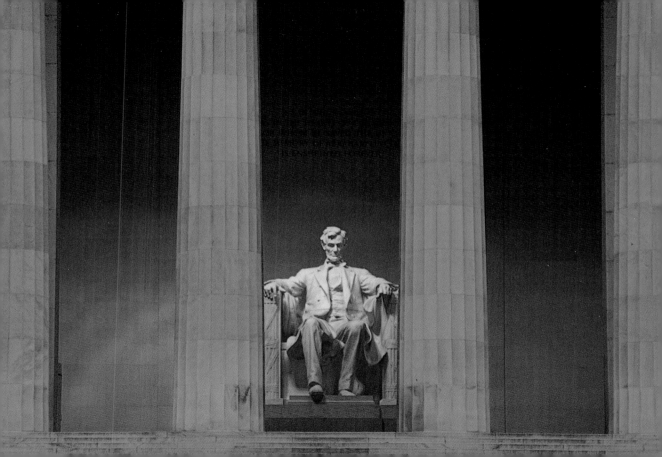

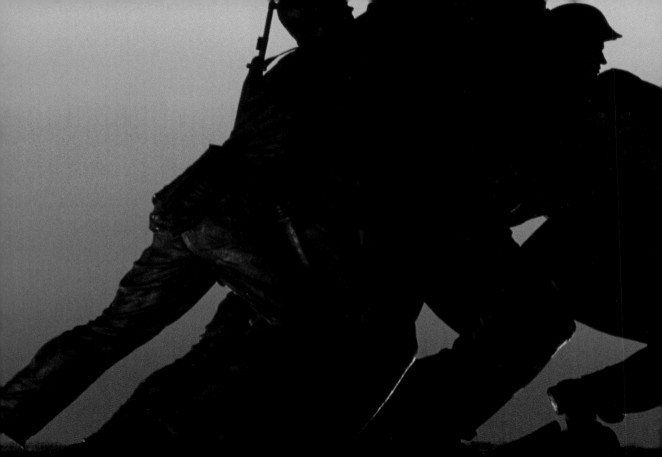

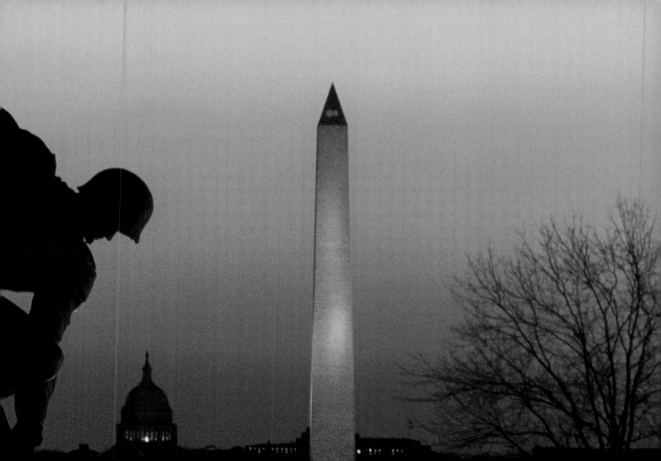

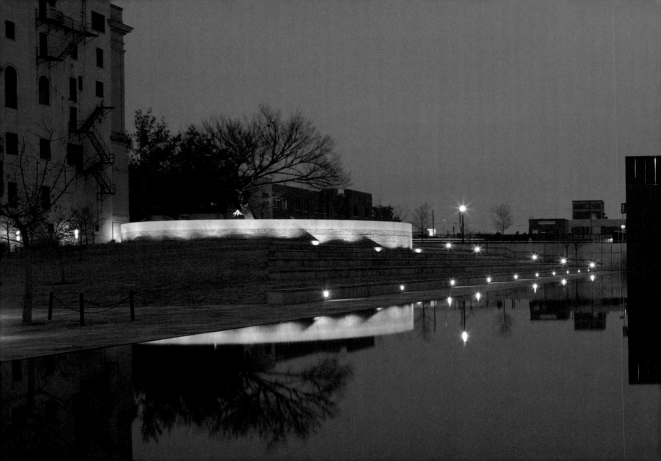

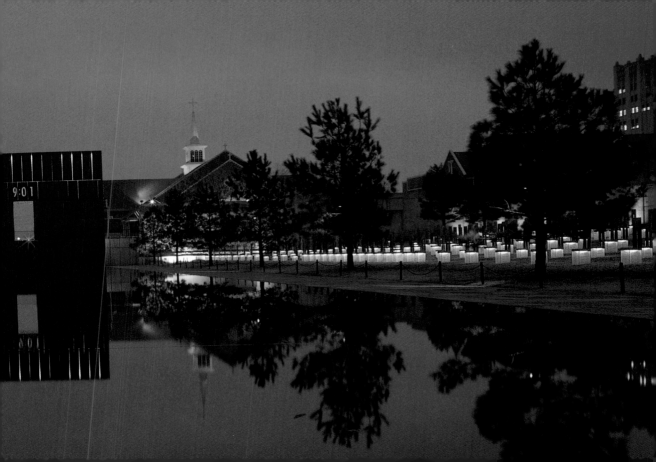

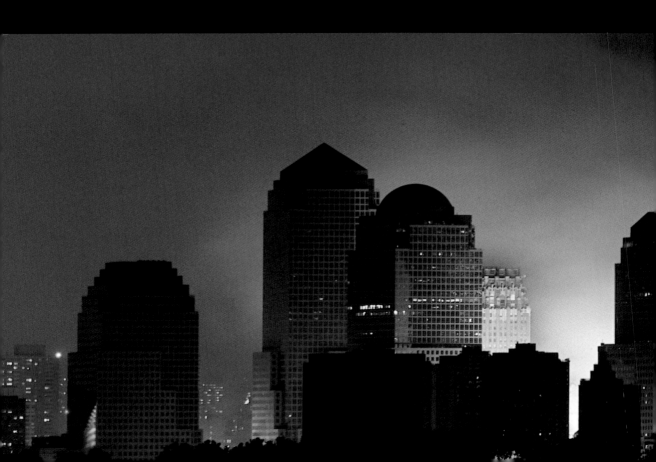

TRAILS

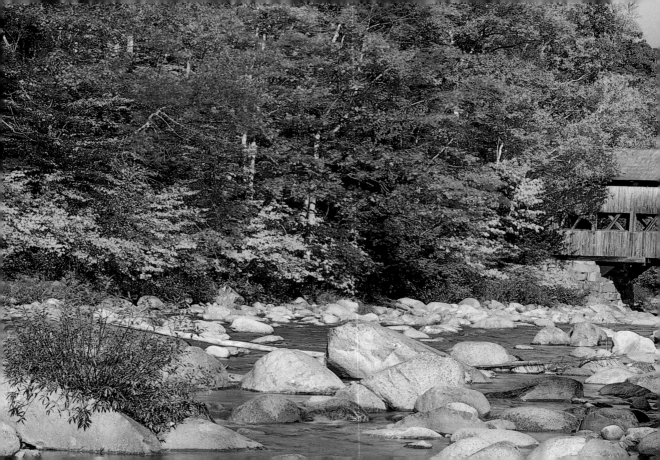

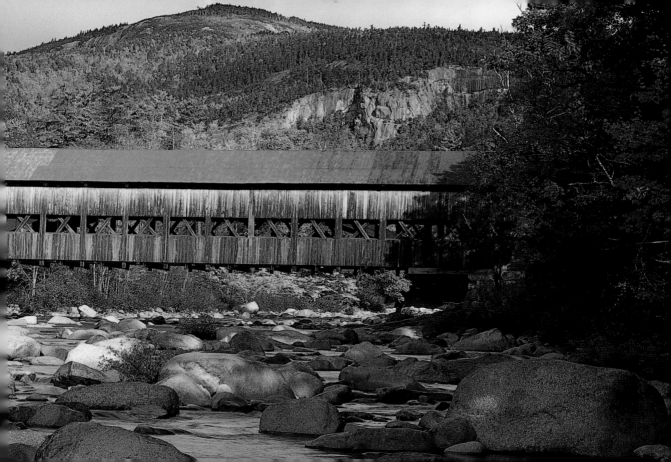

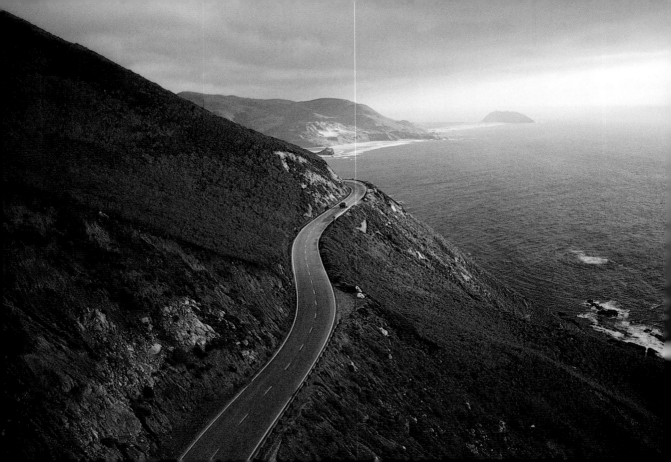

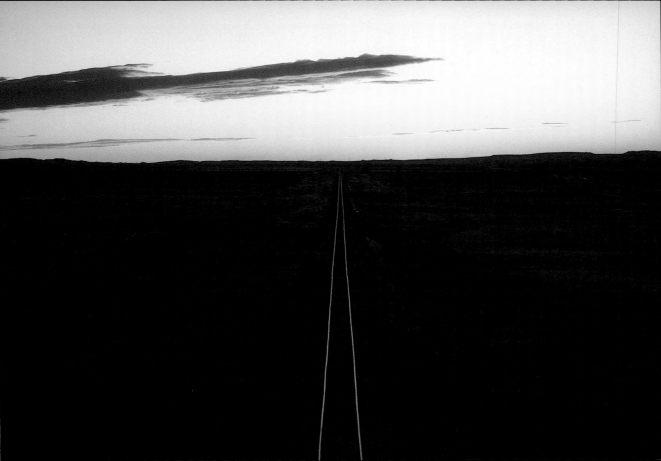

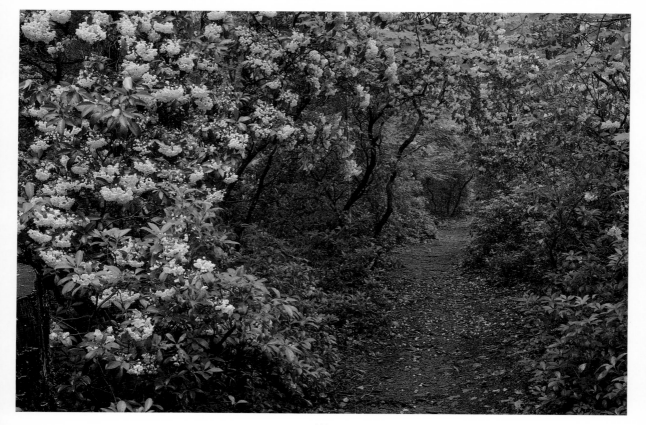

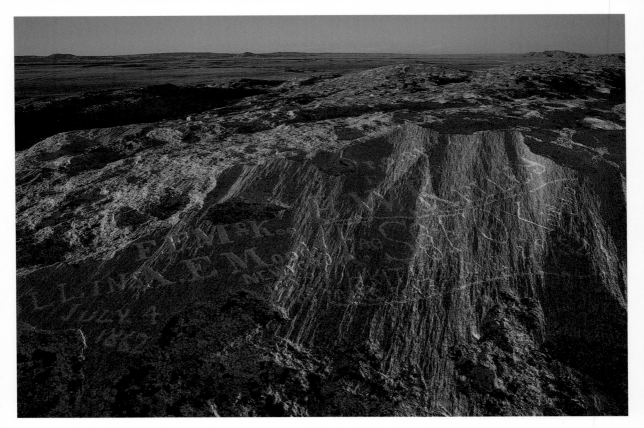

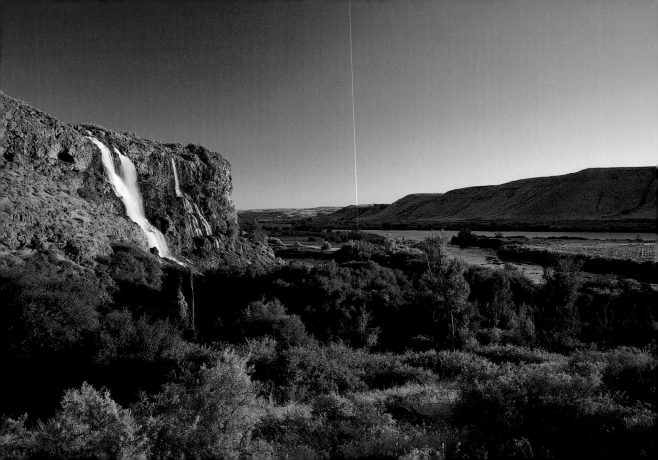

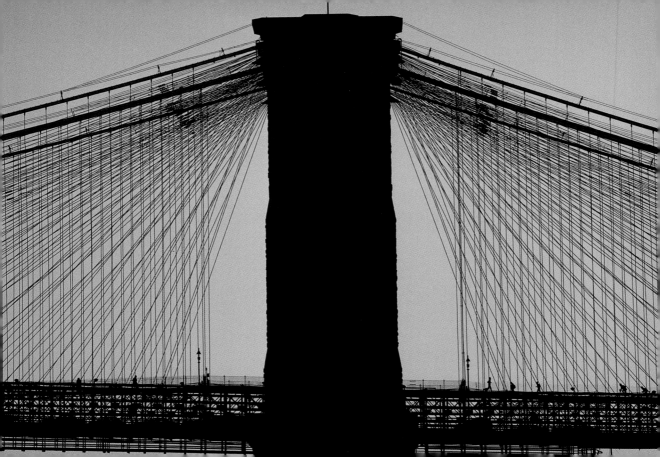

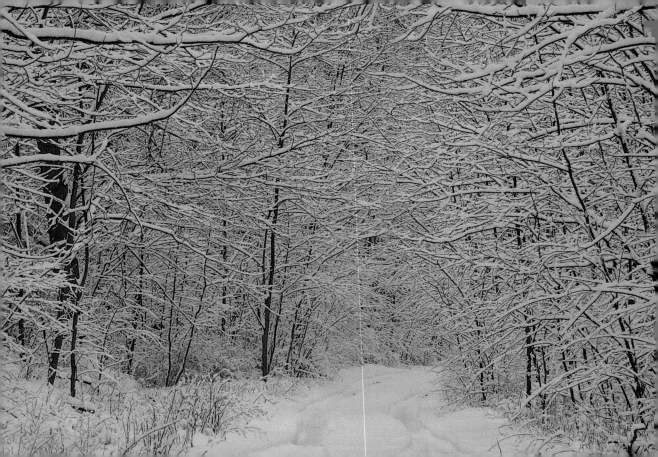

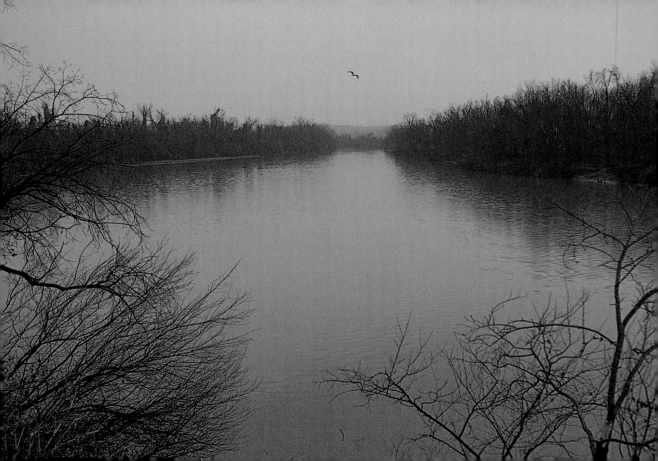

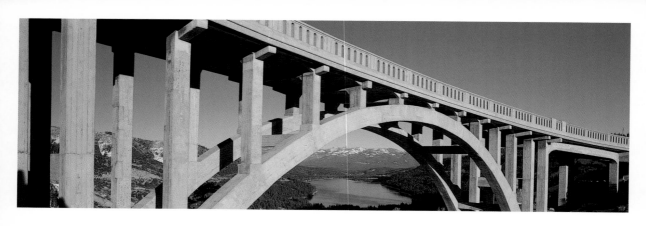

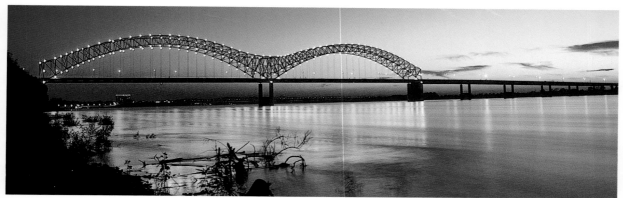

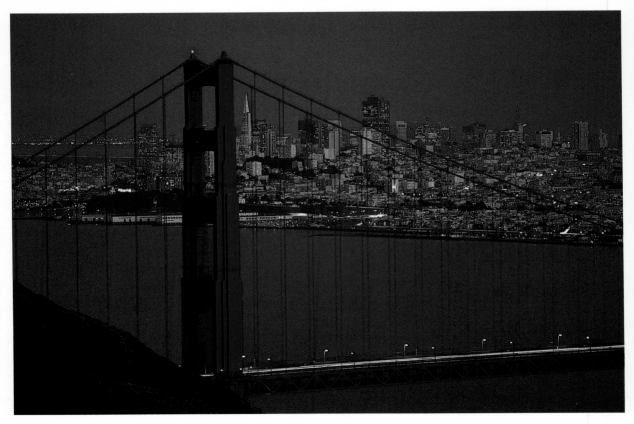

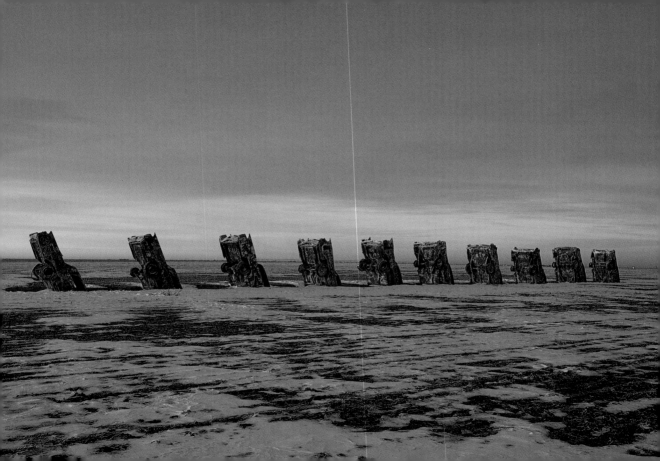

HiSTORIC

ROUTE

66

MOTEL

DIRECT DIALPHONES
QUEEN BEDS
CABLE T.V. H.B.O.
LARGE FAMILY ROOMS

VACANCY

AAA
Approved

Roadkill
66
CAFE
**STEAK
HOUSE**

STEAKS BURGERS

HISTORIC
24 HR REPAIRS
TOWING
66
AUTOMOTIVE

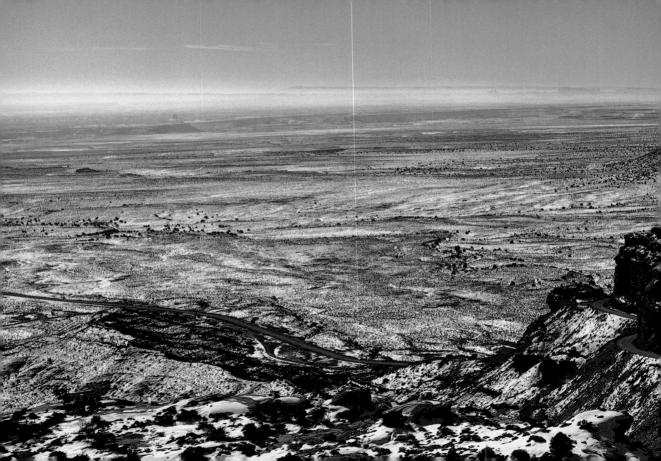

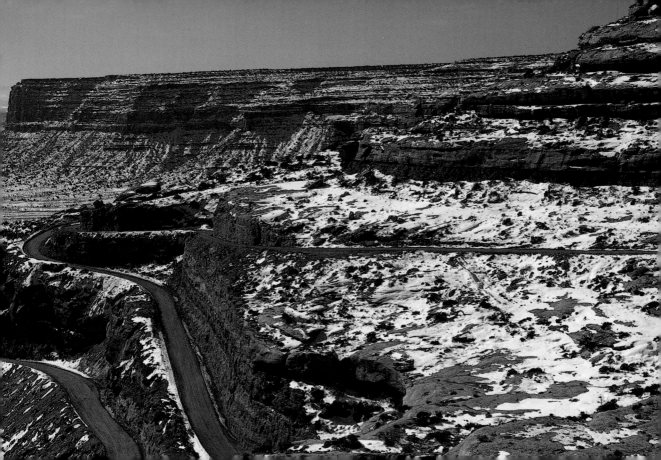

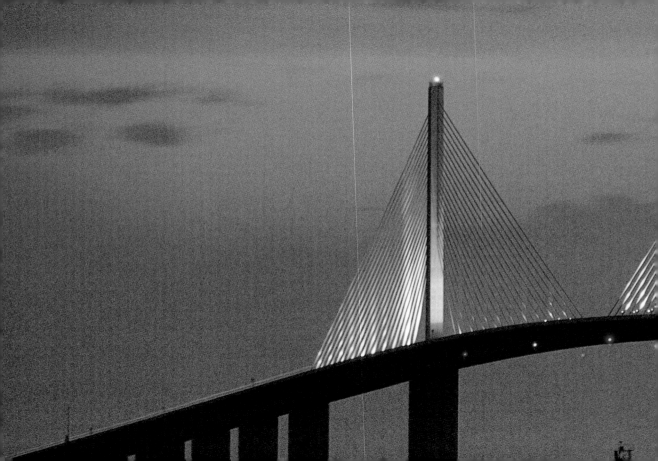

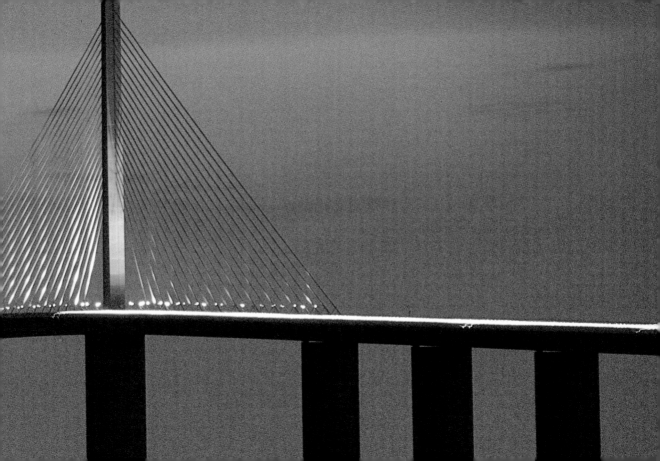

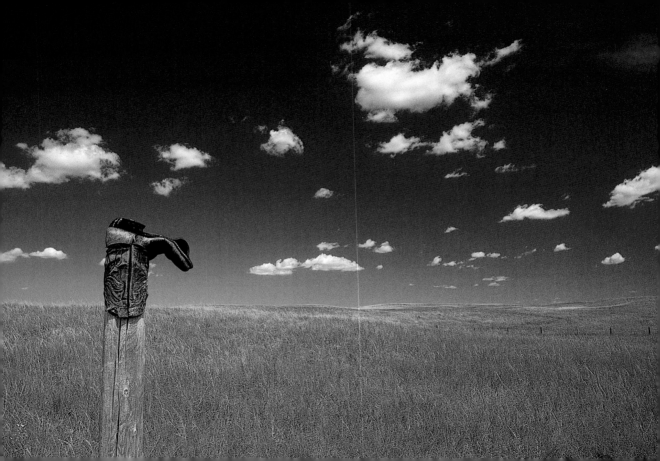

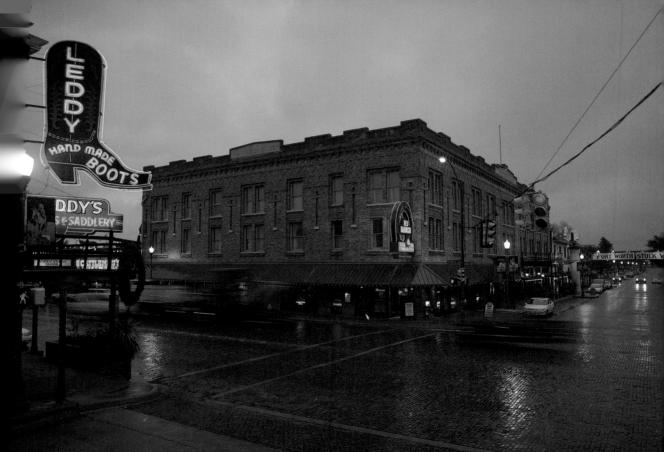

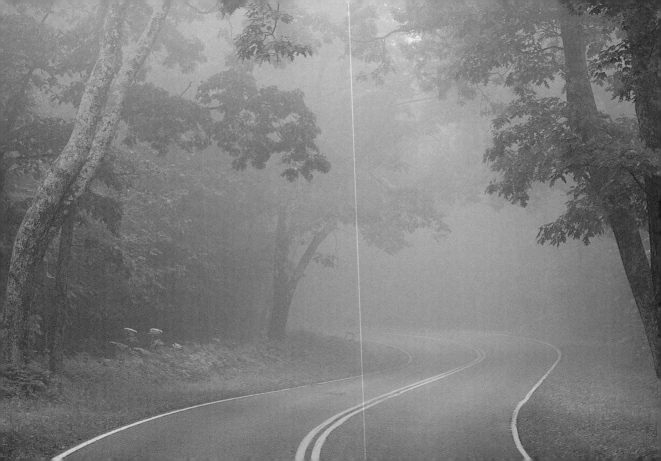

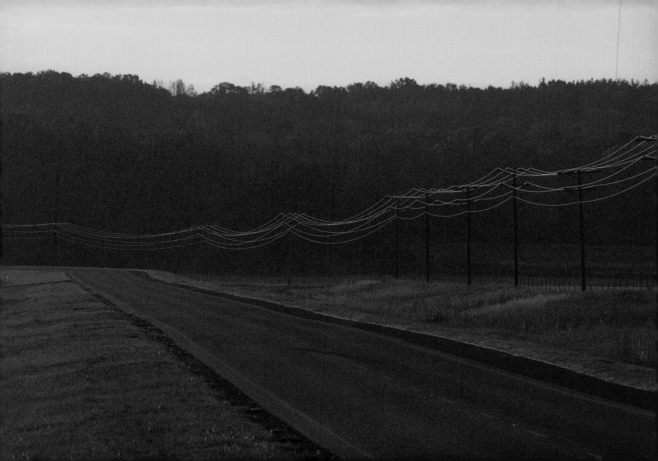

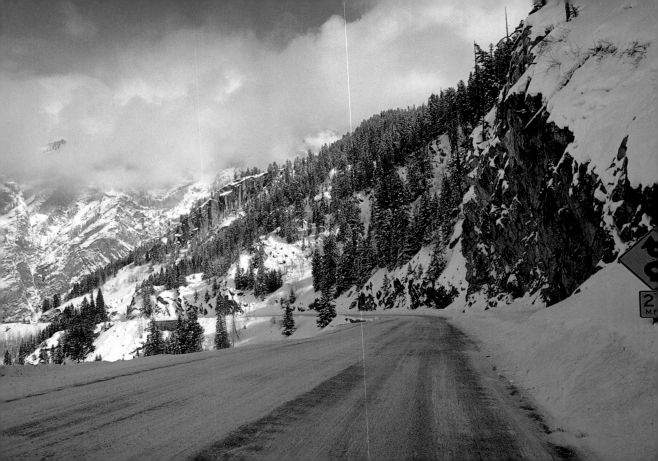

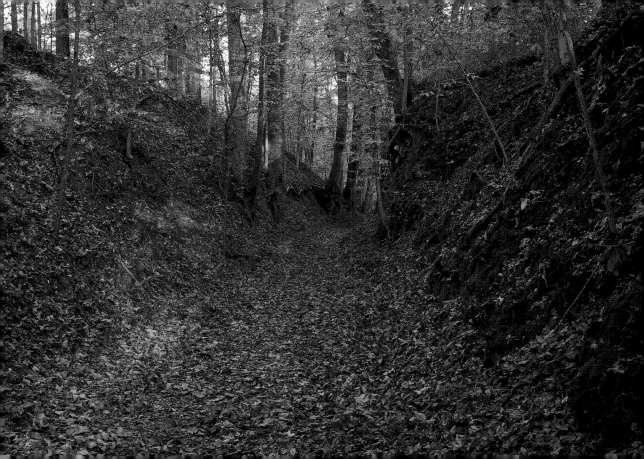

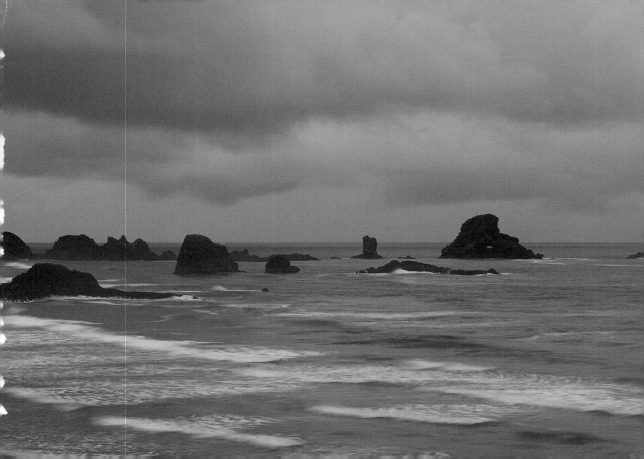

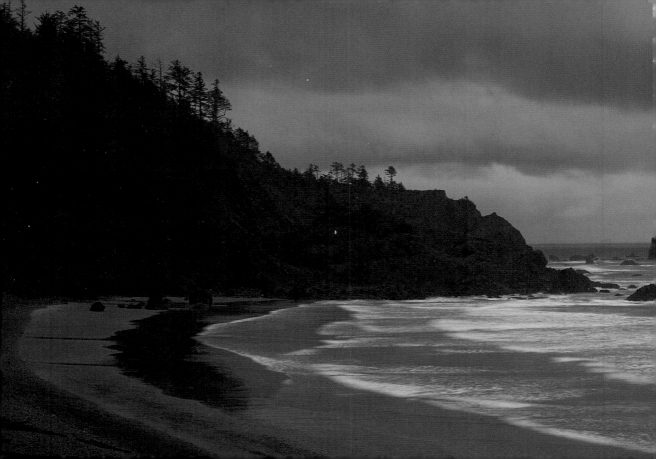

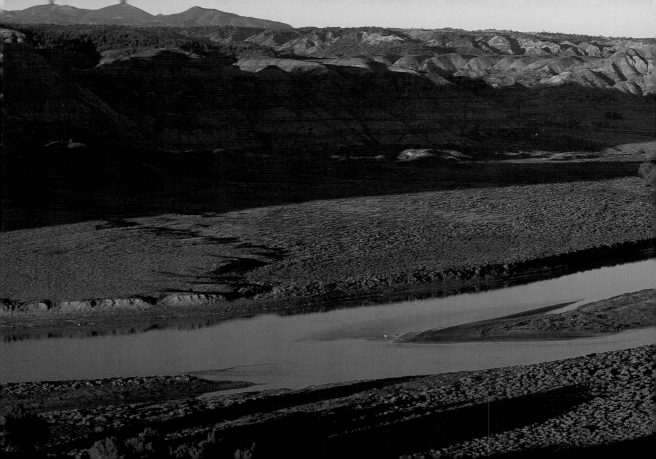

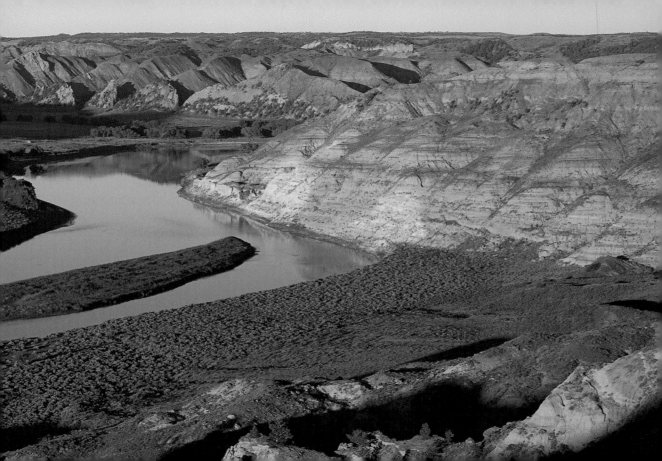

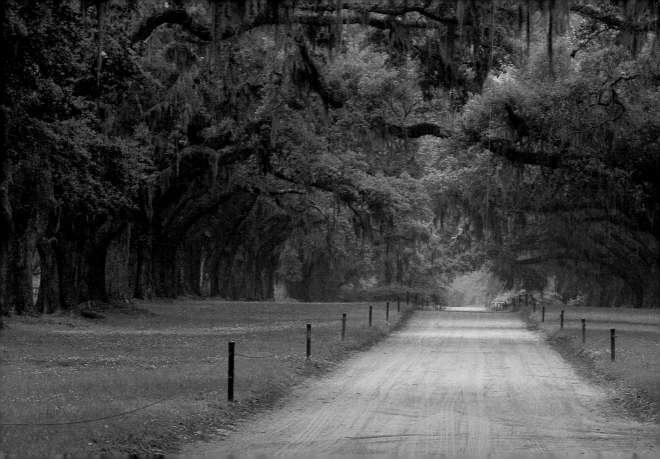

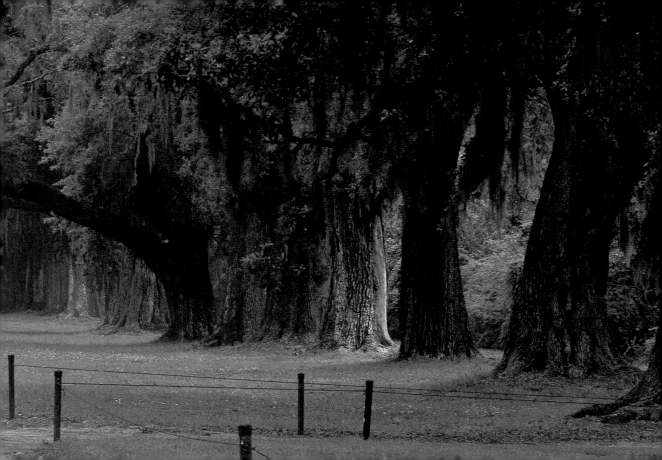

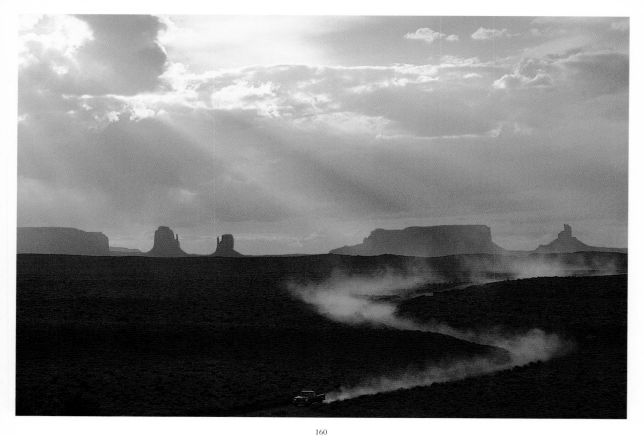

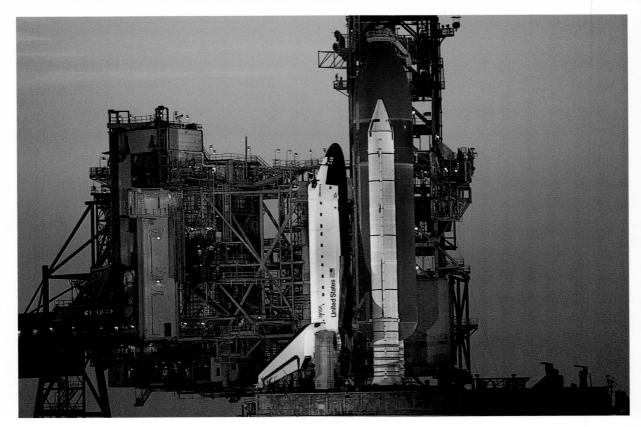

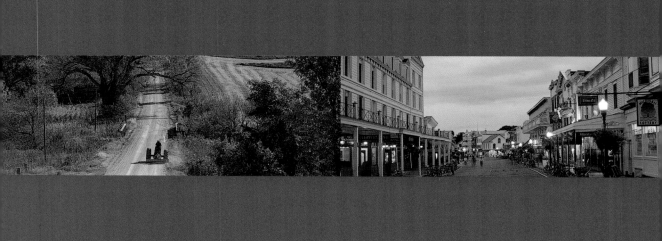

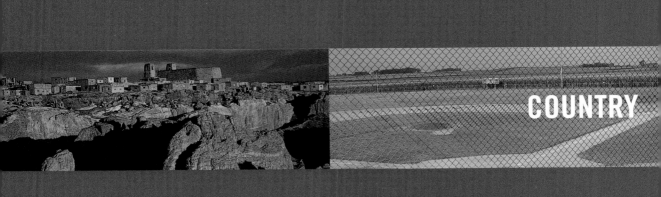

COUNTRY

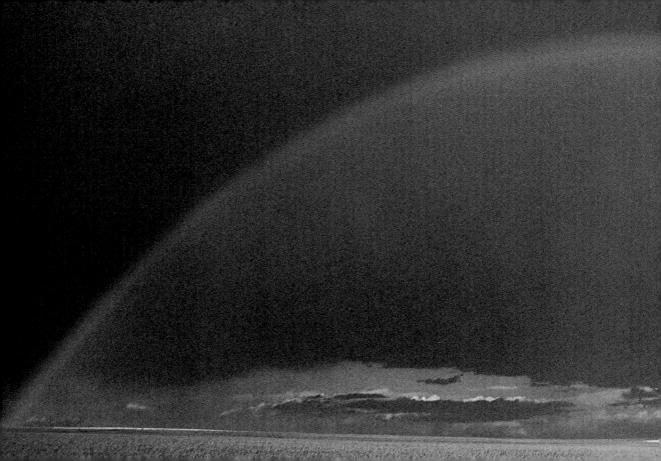

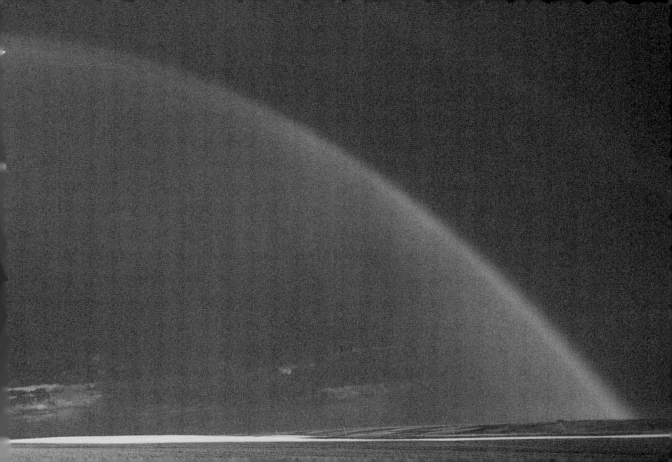

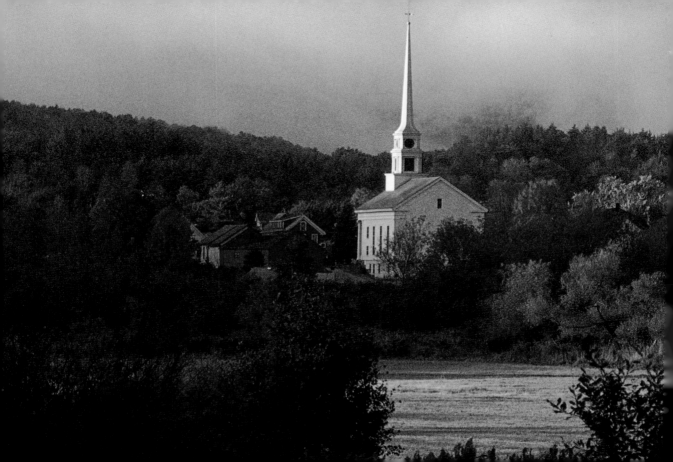

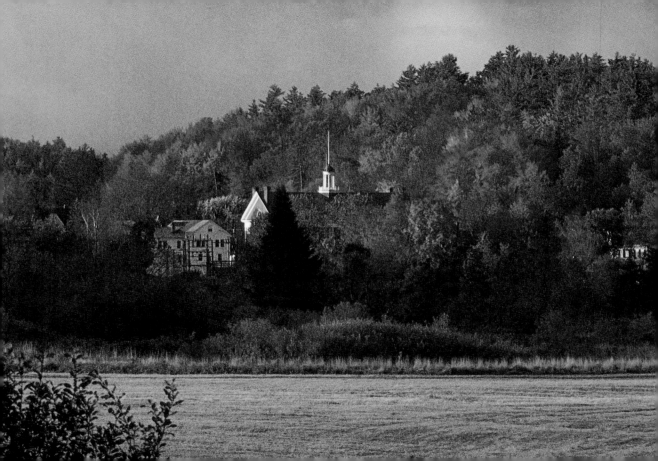

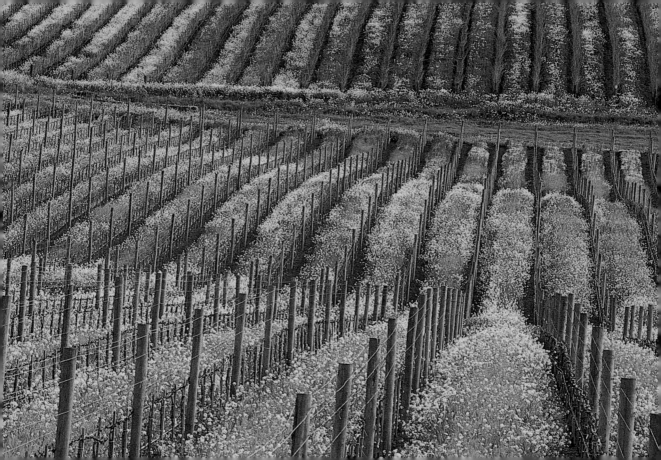

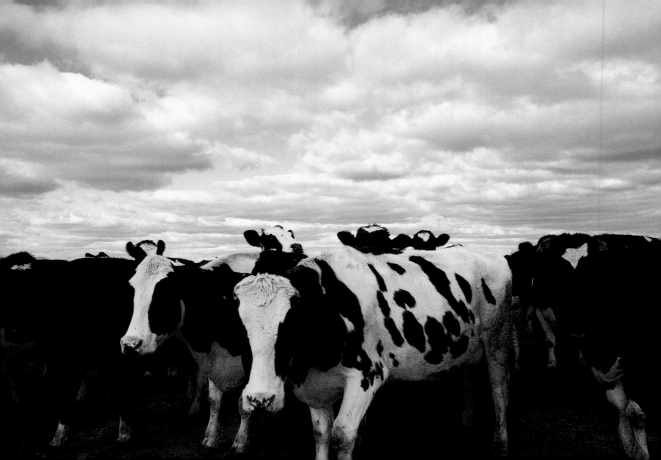

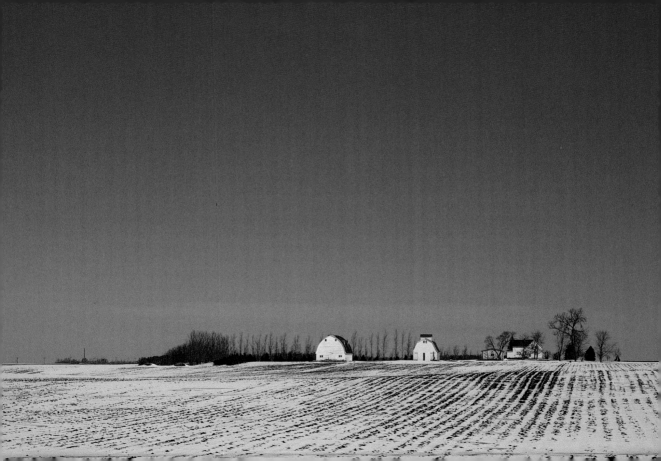

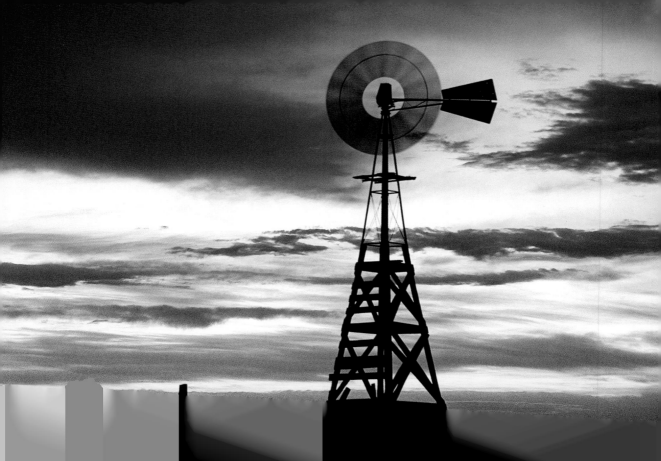

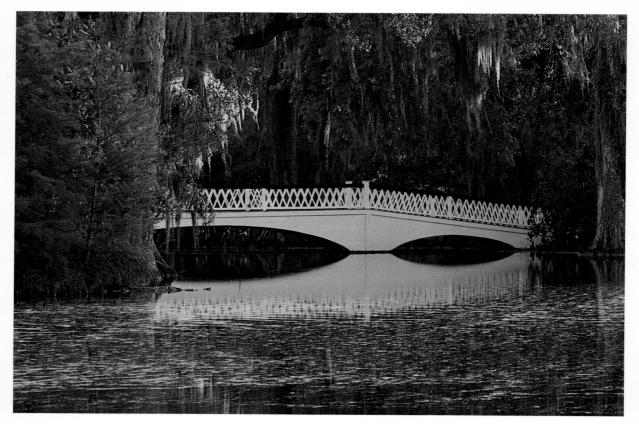

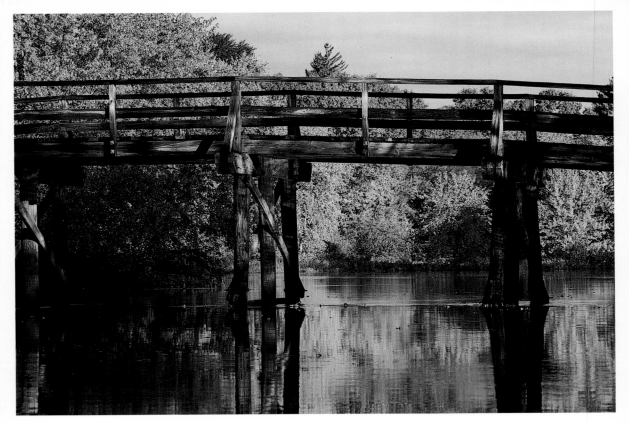

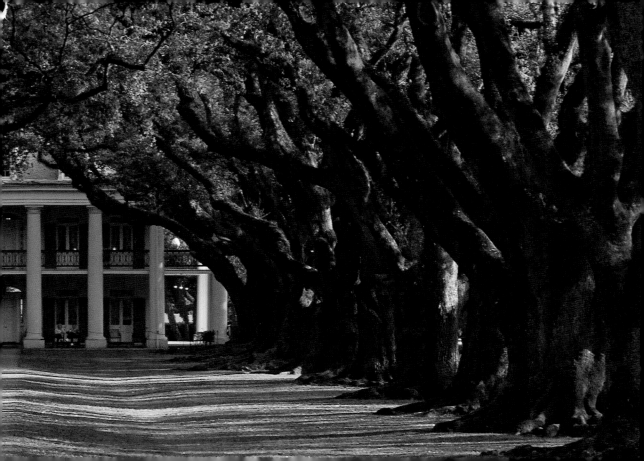

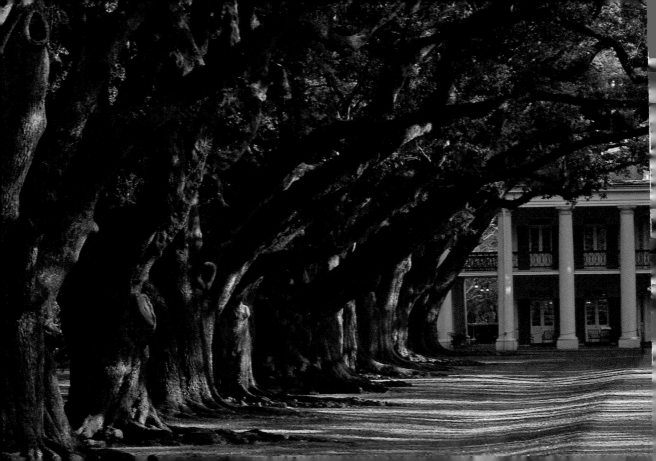

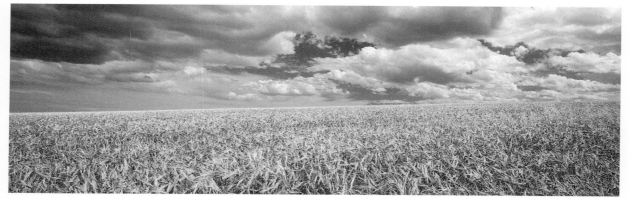

176

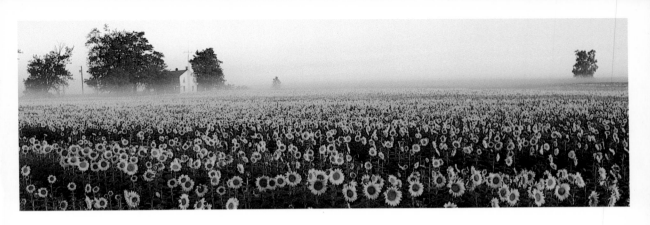

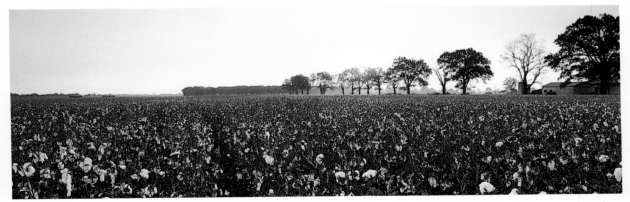

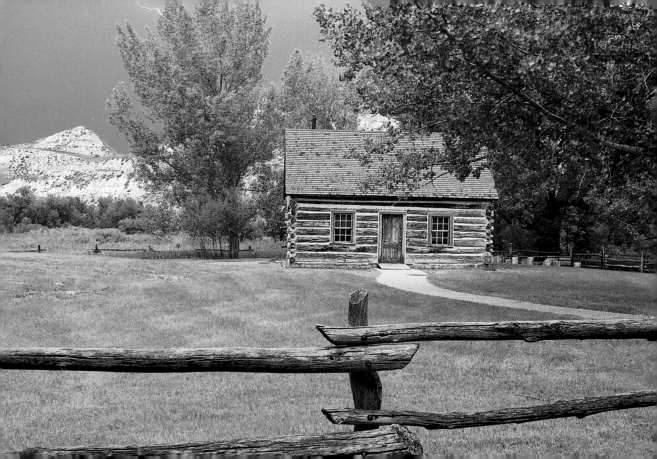

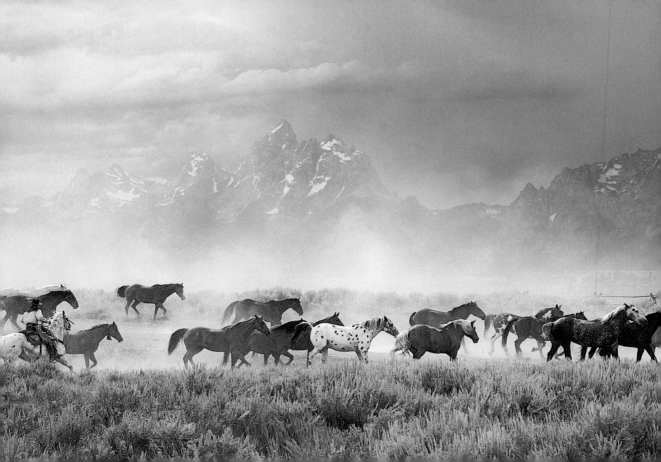

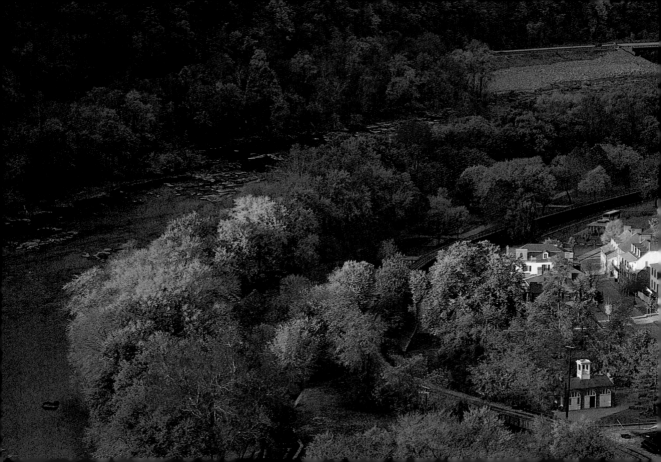

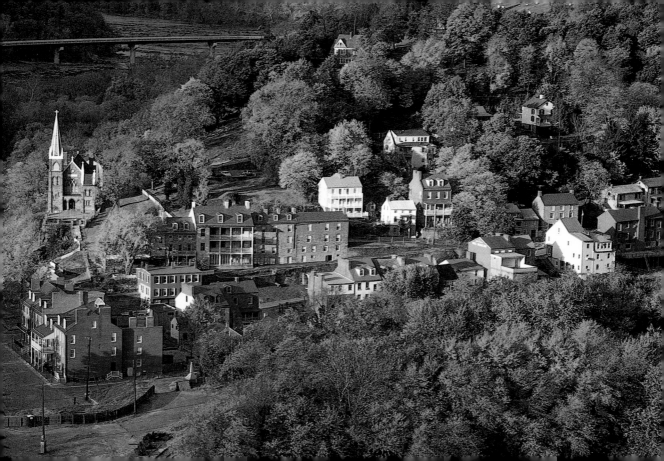

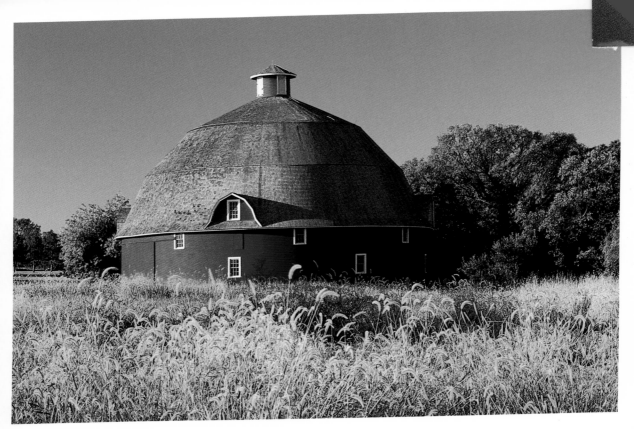

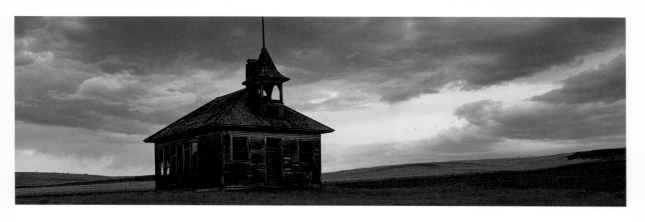

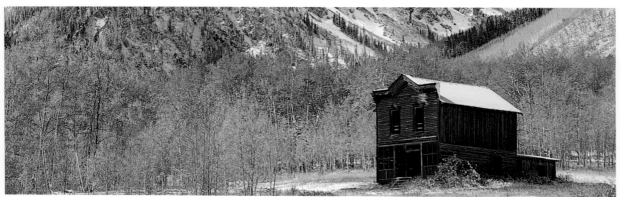

192

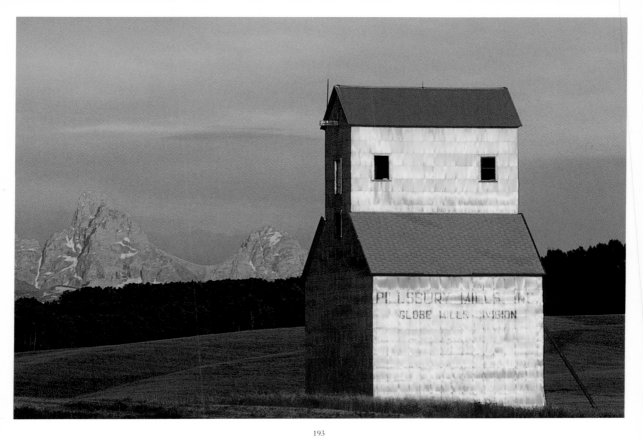

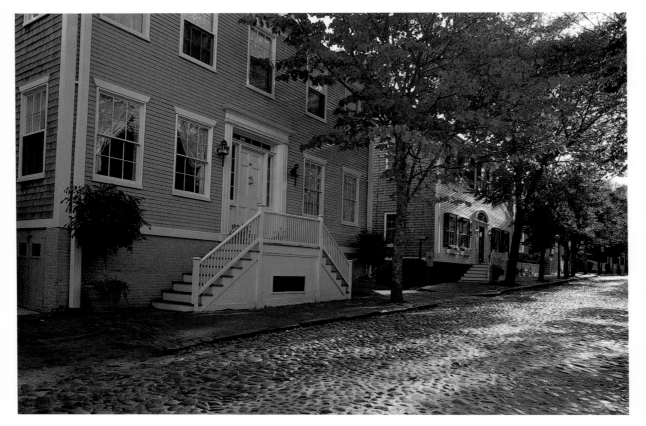

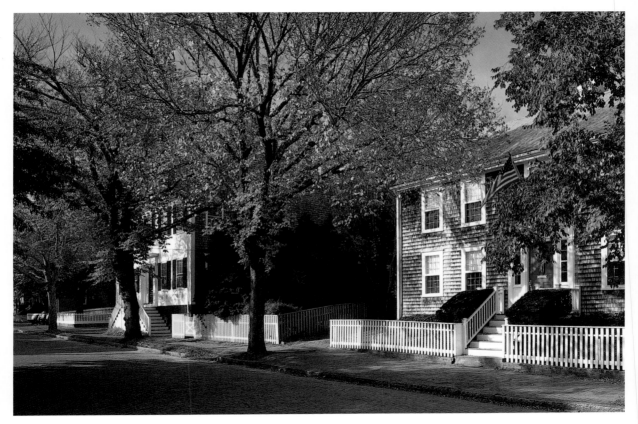

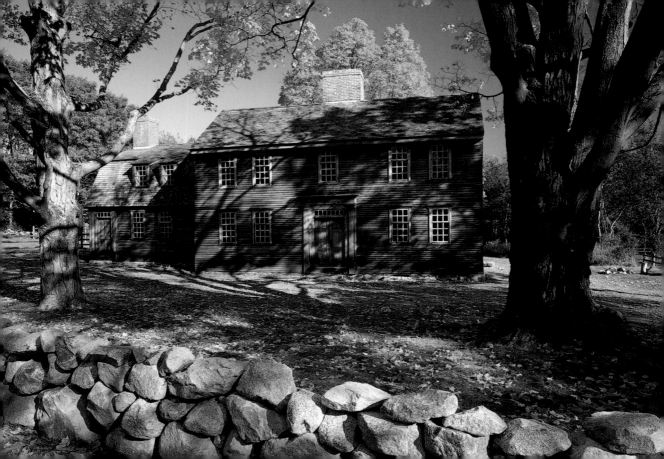

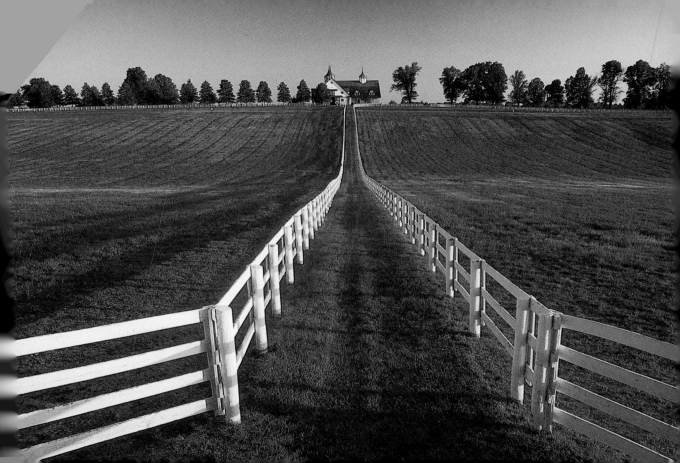

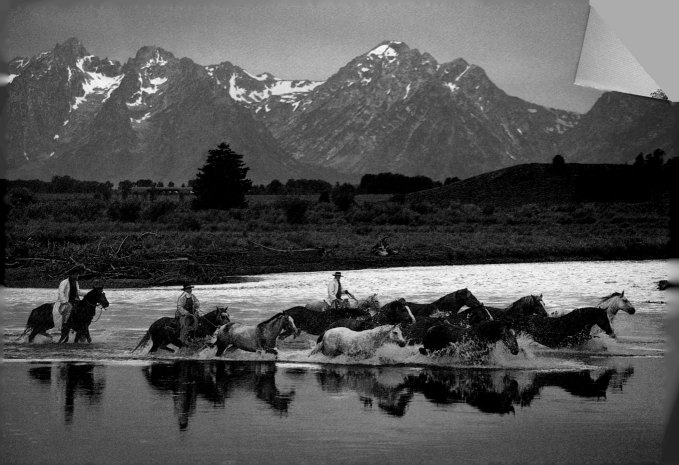

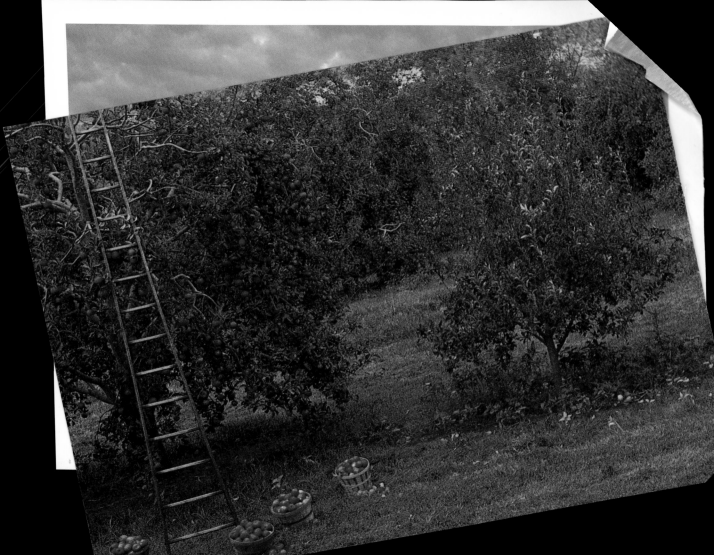

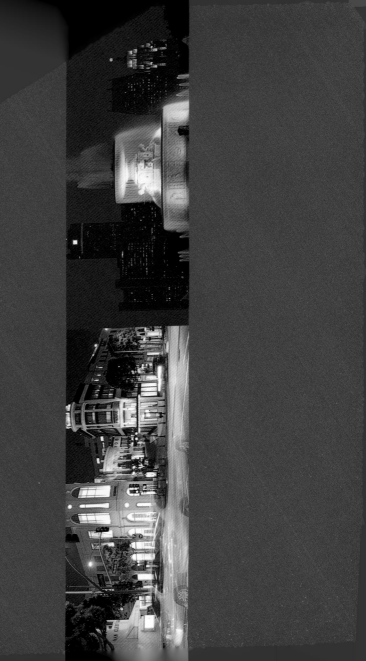

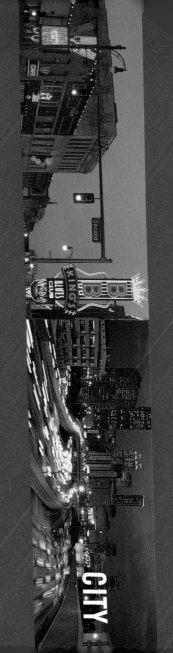

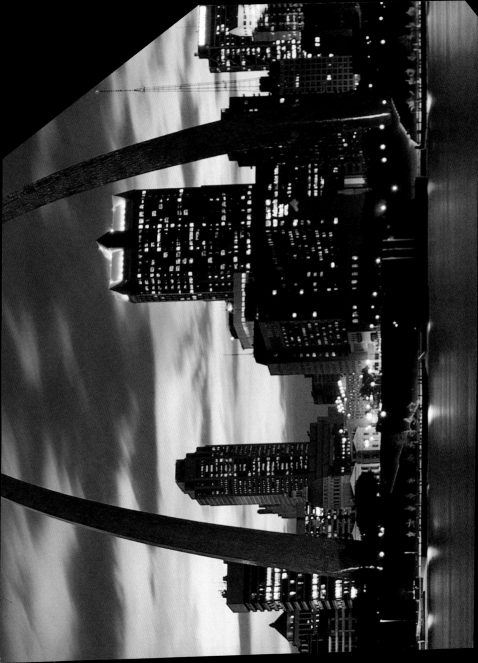

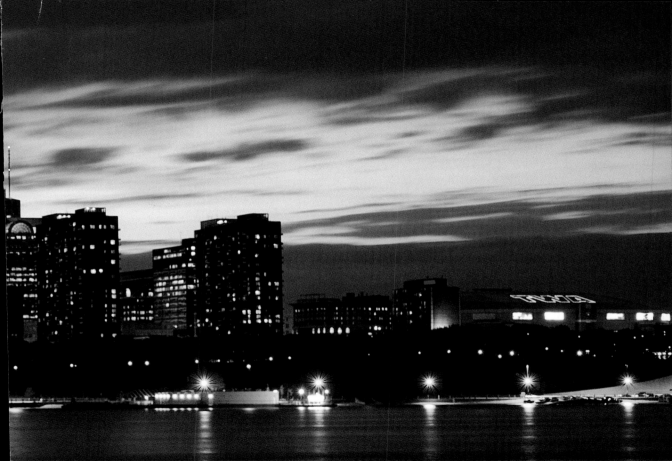

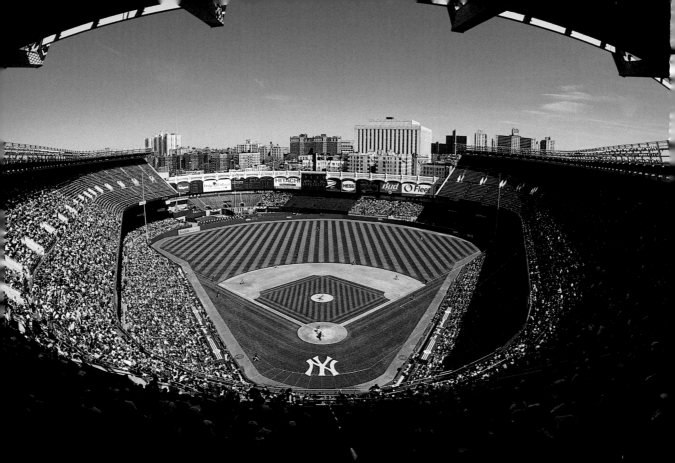

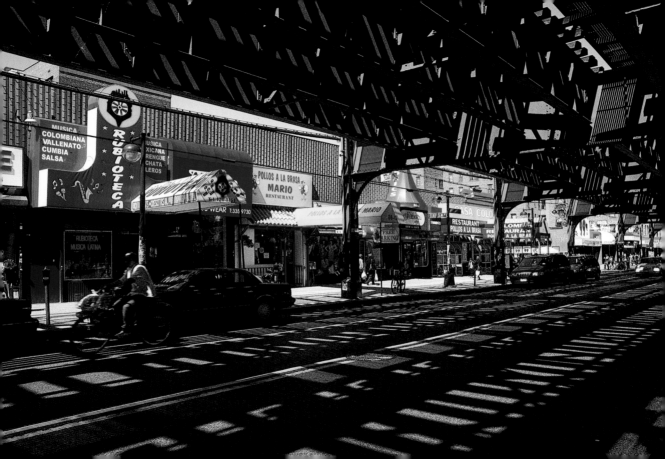

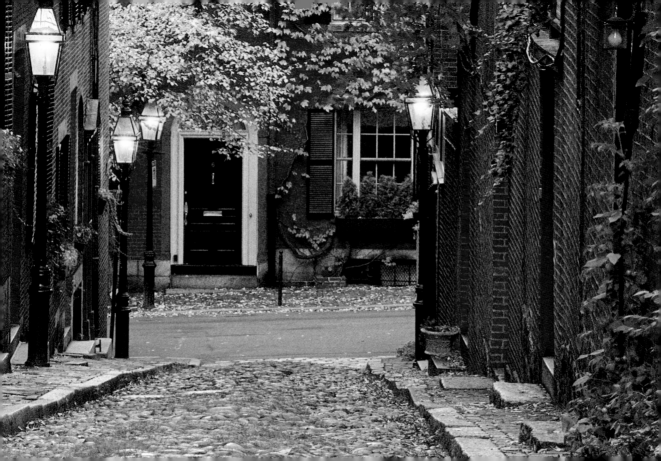

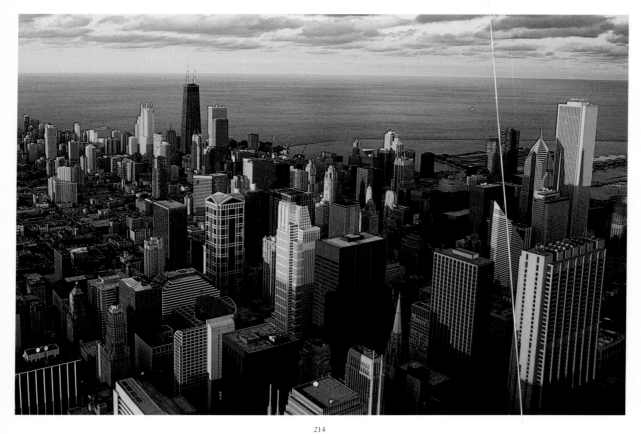

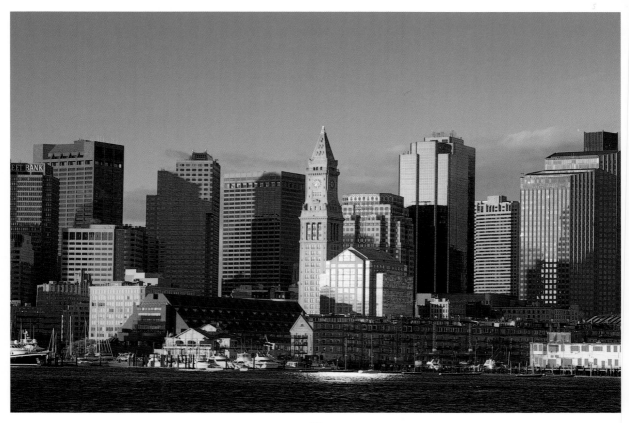

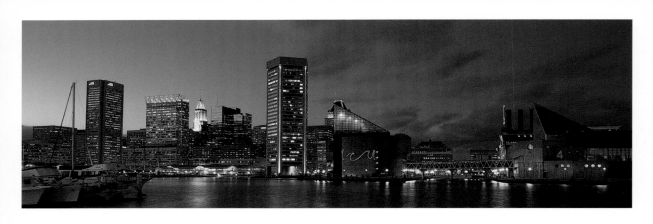

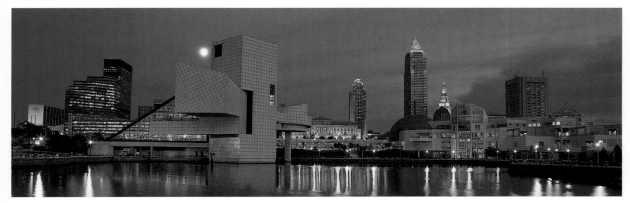

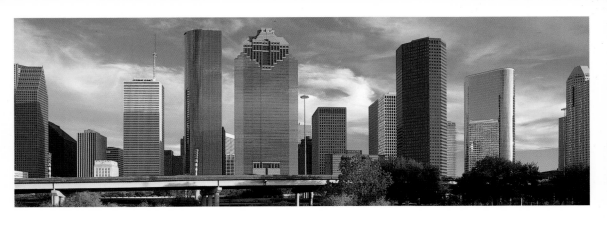

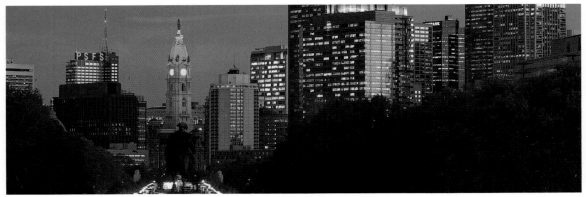

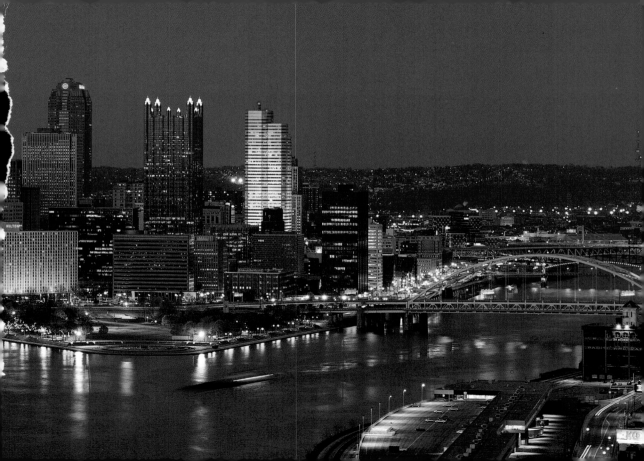

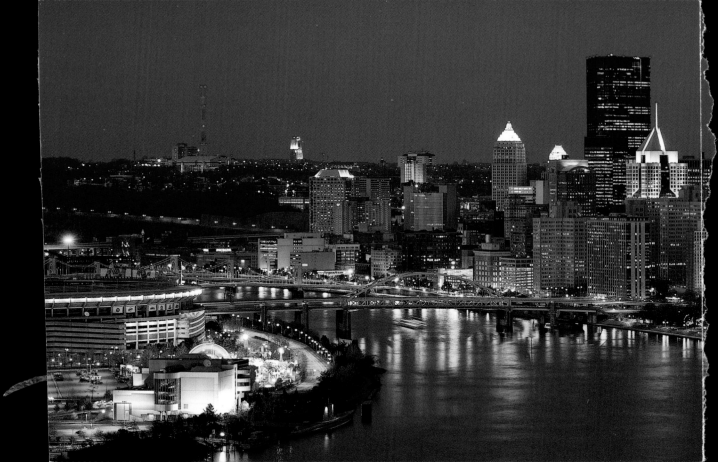

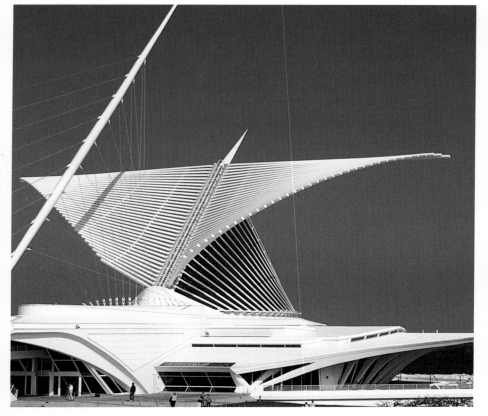

GUGGENHEIM

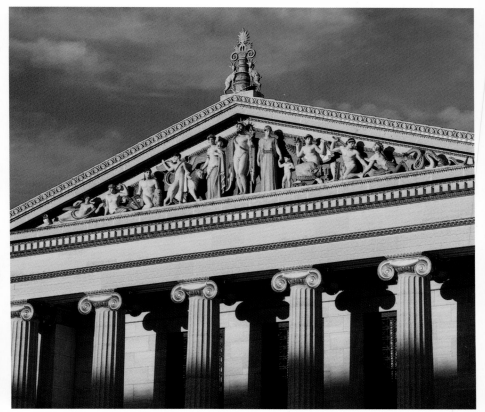

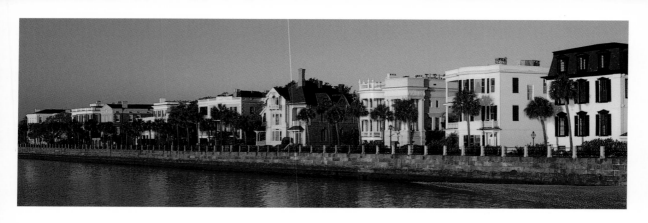

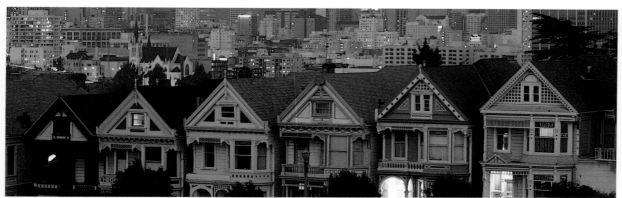

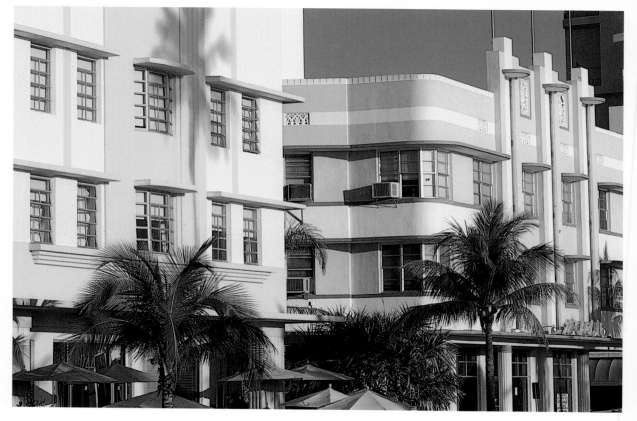

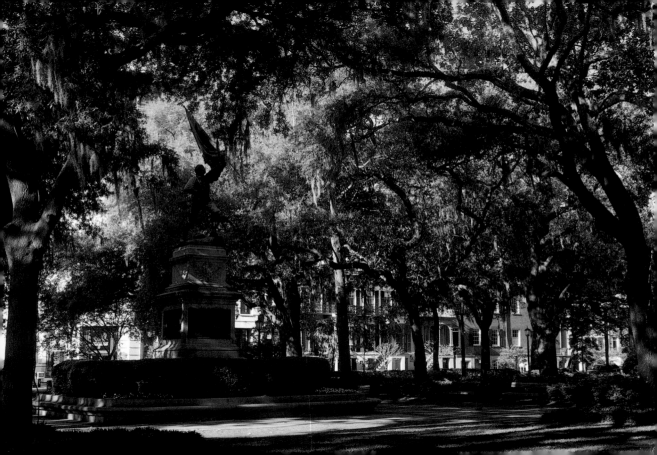

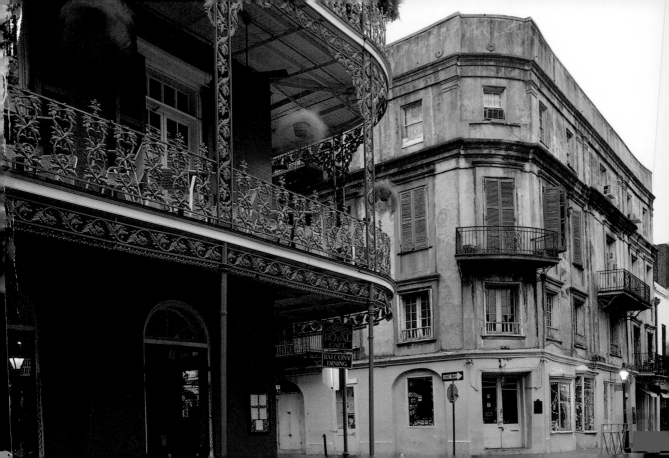

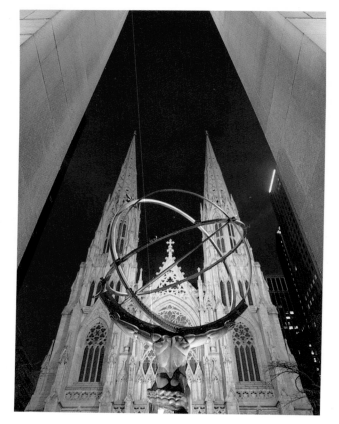

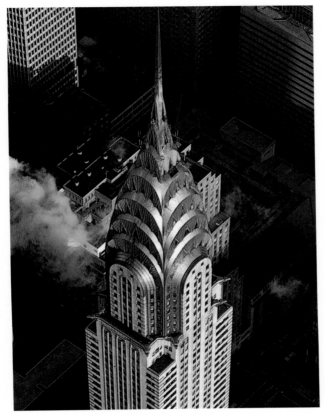

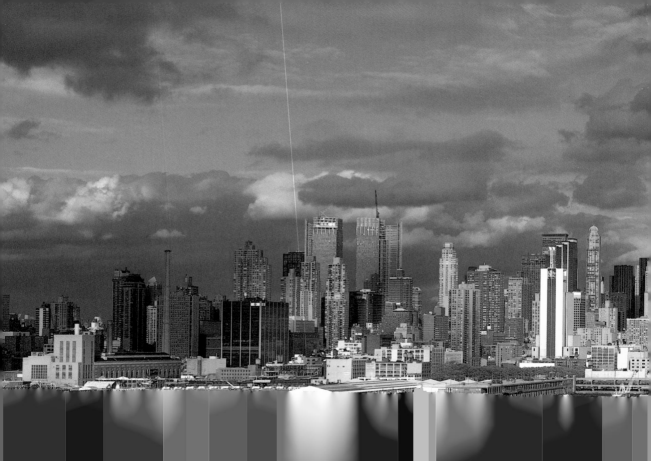

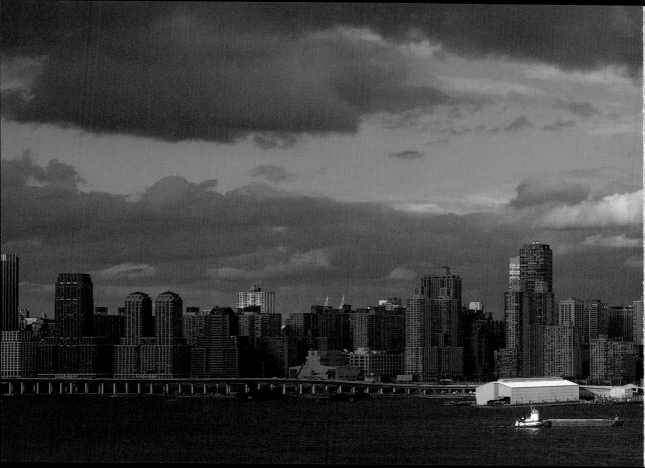

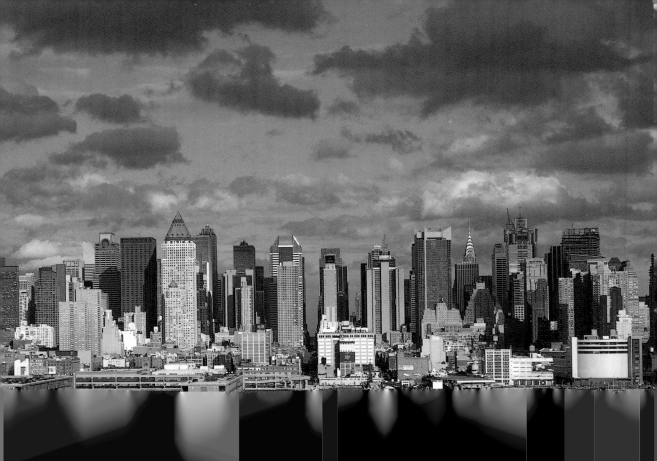

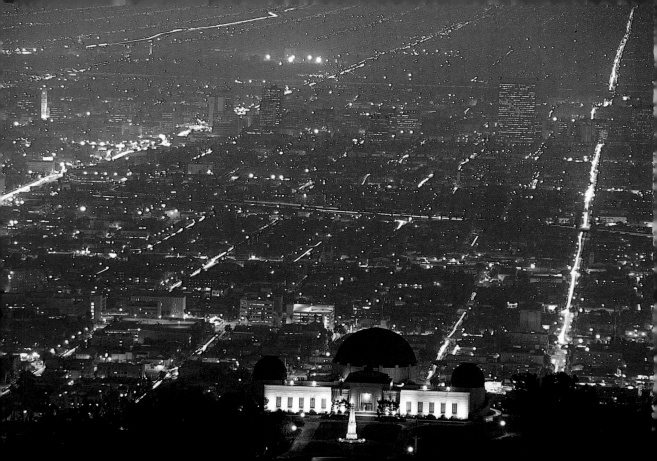

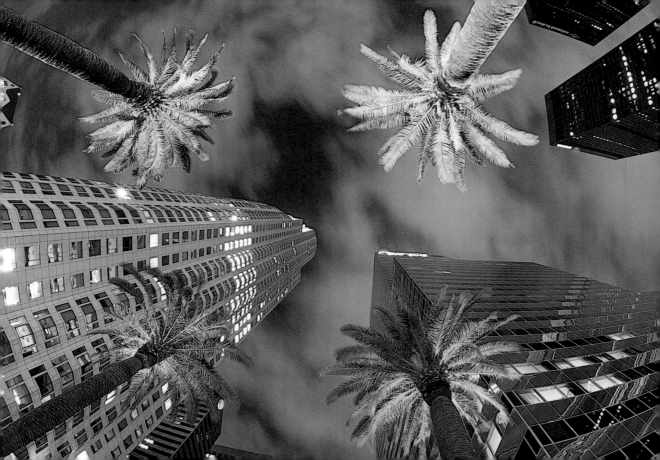

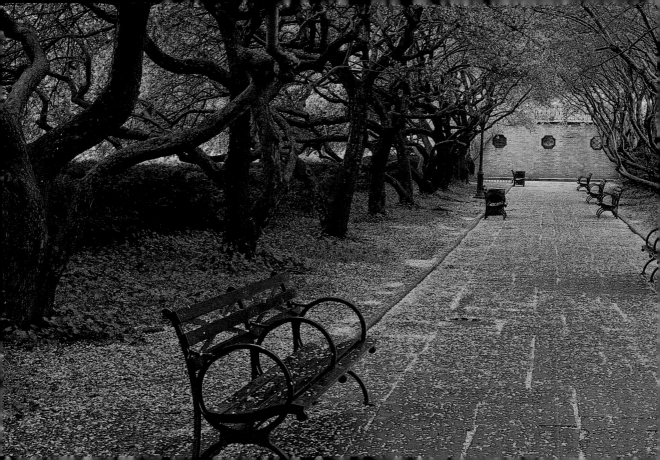

PAGE 28 / PAGE 29 *Left:* North Carolina. Blue Ridge mountains and Blue Ridge Parkway. *Right:* Colorado. Spruce Tree House, Mesa Verde National Park, built by ancestral Puebloans ca. A.D. 1190–1270, and established as a National Park, 1906

PAGE 30 / PAGE 31 *Left:* New York. View from Escarpment Trail in Catskill Park, Hudson River Valley. *Right:* Wyoming. Yellowstone River and Yellowstone Grand Canyon, Yellowstone National Park, established 1872

PAGE 32 / PAGE 33 *Left:* California/Nevada border. Death Valley National Park, established 1994. *Right:* South Dakota. Buffalo in Badlands National Park, established 1978

PAGES 34–35 Colorado. Maroon Bells and Maroon Lake, Aspen

PAGE 36 / PAGE 37 *Left:* South Dakota. Badlands National Park, established 1978. *Right:* Hawaii. Haleakala National Park, Maui, established 1916

PAGE 38 / PAGE 39 *Left:* Colorado. Horse walking in snow, Evergreen. *Right:* Alaska. Fisherman on Chilkoot Lake, Haines

PAGES 40–41 Montana. Saint Mary Lake, Waterton Glacier International Peace Park, established 1906

PAGE 42 / PAGE 43 *Left:* Kansas. Badland formations near Quinter. Route was used by Colorado gold seekers ca. 1859. *Right:* Arizona/Utah border. Navajo nation, Tear Drop Arch, Monument Valley

PAGES 44–45 Alaska. Mount McKinley, highest mountain peak in the United States (20,320 feet), Denali National Park and Preserve, established 1917

PAGES 46–47 New York. Sanford Lake and Hudson River, Adirondack Park

PAGES 48–49 Idaho. Silver Creek, Picabo, renowned for being Ernest Hemingway's favorite hunting and fishing destination

PAGE 50 / PAGE 51 *Left:* California. El Capitan and Horsetail Falls, Yosemite National Park. *Right:* Hawaii. Waterfalls, Kauai. *Left:* Oregon. Warren Creek Waterfall near Columbia River Gorge National Scenic Area. Section of Lewis and Clark's Oregon Trail. *Right:* California. Yosemite Falls, Yosemite National Park

PAGE 52 / PAGE 53 *Left:* Colorado. Aspen trees in Sneffels Mountain Range, part of the San Juan Mountain Range. *Right:* California. Yosemite Valley, Yosemite National Park

PAGE 54 / PAGE 55 *Left:* California. General Sherman Tree, credited with being the largest tree on earth, in Sequoia National Park, established 1890. *Right:* Hawaii. Green spires in Kalalau Valley, also known as "the Valley of the Lepers," Kauai

PAGES 56–59 New York. Hudson River and Hudson Highlands, with United States Military Academy at West Point in background, Garrison. The river is named after Henry Hudson, who sailed the waterway searching for the Northwest Passage, 1609.

PAGES 60–61 Wyoming. Teton Mountain Range and Snake River, Grand Teton National Park, established 1929

PAGES 64–65 Michigan. Grand Sable Dunes and Lake Superior on Pictured Rocks National Lakeshore

PAGES 66–67 New York. Ellis Island, New York City. The island served as an entry point for immigrants to the United States, ca. 1892–1943, and is now part of a National Monument, housing an immigration museum.

PAGE 68 / PAGE 69 *Left:* Texas. Saint Elena Canyon and Rio Grande River, Big Bend National Park, established 1944. *Right:* Maine. Schoodic Point, Acadia National Park, established 1929

PAGES 70–71 Alaska. Chugach National Forest and Portage Glacier

PAGE 72 / PAGE 73 *Left:* Wisconsin. Devils Island, Apostle National Lakeshore. *Right:* Hawaii. Kauai. *Left:* Massachusetts. Cape Cod National Seashore and Atlantic Ocean. Pilgrims first landed here in 1620. *Right:* Florida. Florida Keys

PAGE 74 / PAGE 75 *Left top:* Massachusetts. New Bedford Harbor and Acushnet River, New Bedford. *Left bottom:* Michigan. View of Mackinac Island and Lake Huron from Fort Mackinac. *Right:* Massachusetts. Gloucester and Cape Anne, settled in 1623, and became a center of the fishing industry—America's oldest industry

PAGE 76 / PAGE 77 *Left:* Alaska. Haines. *Right:* California. View of Big Sur and the Pacific Ocean

PAGE 78 / PAGE 79 *Left:* North Carolina. Cape Hatteras Lighthouse, built 1870. *Above right*: Maine. Fort Williams Park, Portland Head Light. Authorized for use by President George Washington, 1791. *Below right*: Maine. Pemaquid Point Lighthouse, built 1827

PAGES 80–81 Massachusetts. Cape Cod National Seashore, Old Harbor Lifesaving Station, Race Point

PAGE 82 / PAGE 83 *Left:* Washington. Point of the Arches, Olympic National Park, established 1938. *Right:* Maine. West Quaddy Lighthouse, built 1808. Quaddy Head Park in Lubec is the easternmost terrestrial point—and the first place over which the sun rises—in the continental United States.

PAGE 84 / PAGE 85 *Left:* Ohio. Marblehead Lighthouse, Lake Erie, built 1821. *Right:* Florida. Palm tree and rainbow on Crandon Beach, Key Biscayne

PAGES 86–87 California. Point Reyes National Seashore. Sir Francis Drake landed here in 1579.

PAGES 90–91 South Dakota. Mount Rushmore National Memorial, Black Hills, noted for its giant busts of four United States presidents: George Washington, Thomas Jefferson, Theodore Roosevelt, and Abraham Lincoln, and carved under the direction of sculptor Gutzon Borglum, 1927–41

PAGE 92 / PAGE 93 *Left:* New York. Federal Hall National Memorial and New York Stock Exchange on Wall Street, New York City. George Washington was inaugurated here as the first president of the United States, 1789. *Right:* District of Columbia. United States Supreme Court building, designed by Cass Gilbert, built 1929–35

PAGE 94 / PAGE 95 *Left:* Tennessee. Rhea County Courthouse and Museum, Dayton. Site of the Scopes "Monkey" Trial, 1925. *Right:* District of Columbia. Capitol building. Terracesand grounds designed by Frederick Law Olmsted, built 1869–1902

PAGE 96 / PAGE 97 *Left:* Florida. Castillo de San Marcos National Monument in Saint Augustine, built by the Spanish, 1672. *Right:* Florida. Dry Tortugas National Park, Fort Jefferson, established 1992

PAGE 98 / PAGE 99 *Top left:* California. Monument at the Manzanar War Relocation Center. The center was one of ten camps at which Japanese American citizens and resident Japanese aliens were interned during World War II. *Top right:* Virginia. Arlington National Cemetery, established 1864. The cemetary honors the dead of every military conflict since the American Civil War. *Bottom left:* Montana. Little Bighorn Battlefield National Monument on Custer Hill. The Cheyenne and Lokota warriors defeated the United States Cavalry led by Lieutenant Colonel George Armstrong Custer, 1876. *Bottom right:* Georgia. Camp Sumter, also known as Andersonville, was one of the largest of many Confederate military prisons established during the Civil War. *Right:* New York. United States Military Academy at West Point, founded 1802

PAGE 100 / PAGE 101 *Left:* Pennsylvania. Statue of Brigadier General G. K. Warren stands atop Little Round Top in Gettysburg National Military Park, overlooking the Valley of Death. *Right:* Virginia. George Washington's home at Mount Vernon, built 1743

PAGE 102 / PAGE 103 *Left:* Massachusetts. National Monument, Boston, commemorating Colonel Robert Gould Shaw and his regiment. Shaw was commander of the first Massachusetts regiment of Black men to serve in the Civil War, estblished 1897. *Right:* Maryland. Antietam National Battlefield, Sharpsburg. Civil War site, marking the end of General Robert E. Lee's first invasion of the North, 1862

PAGE 104 / PAGE 105 *Left:* Texas. The Alamo, San Antonio. Mission and site of siege by Mexican forces, 1836. *Right:* Pennsylvania. Independence National Historical Park, Philadelphia. The Liberty Bell commemorates the date of independence of the United States of America, July 8, 1776.

PAGES 106–107 Nevada. Silver Springs, Fort Churchill State Historic Park, built 1860

PAGES 108–109 Idaho. White Bird Battlefield in Nez Percé Historical Park. First battle of the Nez Percé War was fought here, 1877

PAGE 110 / PAGE 111 *Left:* Virginia. The Rotunda at University of Virginia in Charlottesville, designed by Thomas Jefferson, 1819–1826. *Right:* Massachusetts. Massachusetts Hall at Harvard University in Cambridge, the oldest American university, founded 1636

PAGES 112–113 Rhode Island. Providence State Capitol rotunda, designed by McKim, Mead, & White, built 1904

PAGE 114 / PAGE 115 *Left:* West Virginia. Statue of Abraham Lincoln and State Capitol Building, Charleston. *Right:* Alabama. Dome of the State Capitol Building, Montgomery, designed and built by George Nichols, 1851. *Left:* Texas. State Capitol, Austin, designed by Elijah E. Myers, built 1882–88. *Right:* Minnesota. State Capitol Building, Saint Paul, designed by Cass Gilbert, built 1893-1904

PAGE 116 / PAGE 117 *Left:* New York. Hindu Temple of North America, Queens, New York City. *Center:* New York. Saint Paul's Chapel (built 1766) and memorial lights for victims of the attack on the World Trade Center on September 11, 2001. *Right:* Texas. San Jose Mission, San Antonio Missions National Historic Park, founded 1720

PAGE 118 / PAGE 119 *Left:* New Mexico. San Miguel Chapel, Santa Fe. Oldest church in the United States, built 1610. *Right:* South Carolina. The oldest synagogue in the United States, built 1840. *Left:* Colorado. United States Air Force Academy Chapel in Colorado Springs. *Right:* Connecticut. First Church of Christ, Farmington, founded 1652

PAGE 120 / PAGE 121 *Left:* District of Columbia. Vietnam Memorial, designed by Maya Ying Lin, built 1982. *Right:* District of Columbia. The Lincoln Memorial, designed by Henry Bacon, built 1914–17

PAGES 122–123 Virginia. The United States Marine Corps War Memorial, atop a promontory at the north end of Arlington National Cemetery, erected 1954

PAGES 124–125 Oklahoma. Gates of Time, National Memorial, Oklahoma City honoring victims of 1995 attack on the Murrah building, erected 2000

PAGES 126–127 New York. Statue of Liberty and construction lights in lower Manhattan after attack on the World Trade Center, 2001

PAGES 130–131 New Hampshire. Albany Bridge on Kancamagus Highway in Mountains National Forest, built 1858

PAGE 132 / PAGE 133 *Left:* California. Big Sur is located on the central California coast twenty-six miles south of Carmel, and between the Ventana Wilderness Area and the Los Padres National Forest. *Right:* Wyoming. Railroad tracks, Douglas, near Medicine Bow National Forest

PAGE 134 / PAGE 135 *Left:* Virginia. Mountain laurel in the Blue Ridge Mountains, Shenandoah National Park, established 1935. Designated Appalachian National Scenic Trail, 1968. *Right:* Wyoming. Independence Rock State Historic Site, named "the Great Register of the Desert" and part of the Oregon Trail

PAGE 136 / PAGE 137 *Left:* Idaho. Thousand Springs and Snake River, near Twin Falls on the Oregon Trail. *Right:* New York. Brooklyn Bridge, designed by John A. Roebling, built 1883

PAGE 138 / PAGE 139 *Left:* New York. Snowy road on Mount Tremper, Catskill Park. *Right:* Arkansas. Fort Smith National Historical Site on Arkansas River, dubbed "the Trail of Tears"

PAGE 140 / PAGE 141 *Above left:* California. Rainbow Bridge over Donner Lake, built 1925. *Below left:* Tennessee. Hernando de Soto Bridge, Mississippi River, connecting Memphis, TN, to Memphis, AK, built 1973. *Right:* California. Golden Gate Channel, connecting San Francisco Bay to the Pacific Ocean, and the Golden Gate Bridge, built 1933–1937

PAGE 142 / PAGE 143 *Left:* Texas. Cadillac Ranch, Amarillo, created 1974. *Right:* Arizona. Historic Route 66, Seligman. Route 66 is popularly known as "The Mother Road" and "Main Street of America."

PAGES 144–145 Utah. Route 261, near Mexican Hat rock formation

PAGES 146–147 Florida. Sunshine Skyway Bridge over Tampa Bay, Saint Petersburg, built 1987

PAGE 148 / PAGE 149 *Left:* Nebraska. Cowboy boot on post. *Right:* Texas. Fort Worth Stockyards, at corner of Main and Exchange Streets

PAGE 150 / PAGE 151 *Left:* Virginia. Skyline Drive and Blue Ridge Mountains, Shenandoah National Park, established 1929. *Right:* Alabama. Highway 80, known as the "Voting Rights Trail." Selma-to-Montgomery marches helped to bring about the 1965 Voting Rights Act

PAGE 152 / PAGE 153 *Left:* Colorado. San Juan Skyway Scenic Byway. Known as the "Million Dollar Highway," located between Silverton and Ouray, built 1880-1920. *Right:* Mississippi. Natchez Trace National Scenic Trail, near Port Gibson. Trail was used by Natchez, Choctaw, Creek, and Cherokee people, and early European settlers.

PAGES 154–155 Oregon. Cannon Beach in Ecola State Park, explored by Lewis and Clark, 1806

PAGES 156–157 Montana. Missouri Breaks on the Missouri River overlooking Nez Percé National Historic Trail, explored by Lewis and Clark, 1805

PAGES 158–159 South Carolina. Booth Hall Plantation and "the Avenue of Life," Mount Pleasant, near Charleston. Oaks were planted in 1743.

PAGE 160 / PAGE 161 *Left:* Utah/Arizona border. Truck on dirt road in Navajo nation, Monument Valley. *Right:* Florida. John F. Kennedy Space Center is the NASA space vehicle launch facility at Cape Canaveral on Merritt Island.

PAGES 164–165 Wyoming. Rainbow over winter wheat, the Great Plains near Cheyenne

PAGES 166–167 Vermont. The town of Stowe, chartered 1763

PAGE 168 / PAGE 169 *Left:* California. Carneros Creek Vineyard, Napa. *Right:* Wisconsin. Milk cows in Coleman

PAGE 170 / PAGE 171 *Left:* Minnesota. Farm in winter, Lakefield. *Right:* Wyoming. Windmill north of Cheyenne

PAGE 172 / PAGE 173 *Left:* South Carolina. Magnolia Plantation and Gardens outside Charleston. *Right:* Massachusetts. North Bridge, Minute Man National Historical Park. Site near the Battle of Concord, and a symbol of the start of the American Revolutionary War, April 19, 1775

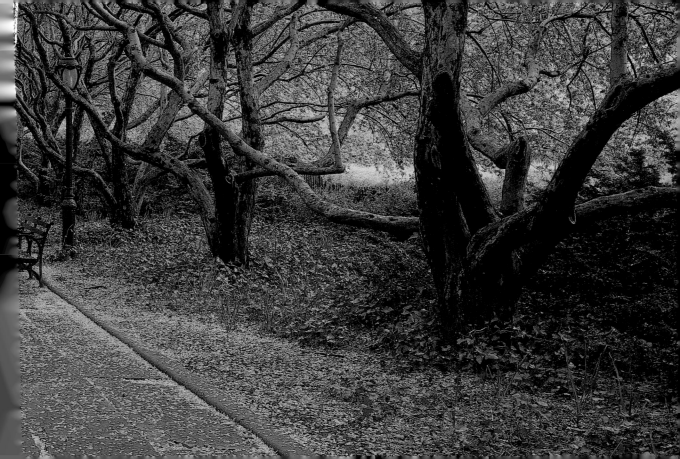